A Thousand and One Fossils

Discoveries in the Desert at Al Gharbia, United Arab Emirates

Peabody Museum of Natural History, Yale University, New Haven
Abu Dhabi Tourism and Culture Authority, United Arab Emirates

Distributed by Yale University Press
New Haven and London

FAYSAL BIBI ANDREW HILL MARK BEECH

Published with support from the Abu Dhabi Tourism and Culture Authority, United Arab Emirates

Distributed by Yale University Press, New Haven and London
yalebooks.com | *yalebooks.co.uk*

Text, photographs and illustrations © 2016 Faysal Bibi, Andrew Hill and Mark Beech, unless otherwise noted. All rights reserved.

Book design by Maura Gianakos (Yale University Printing & Publishing Services) and Mark Saba (Yale Information Technology Services)

Project editor Rosemary Volpe
Peabody Museum of Natural History
Yale University
P. O. Box 208118
New Haven, Connecticut 06520-8118 USA
peabody.yale.edu

Printed in the U.S.A. by GHP Media, Inc., West Haven, Connecticut

Library of Congress Cataloging-in-Publication Data

Names: Bibi, Faysal, 1980- author. | Hill, Andrew P., author. | Beech, Mark J., author.
Title: A thousand and one fossils discoveries in the desert at Al Gharbia, United Arab Emirates / Faysal Bibi, Andrew Hill, Mark Beech.
Description: New Haven, CT : Peabody Museum of Natural History, Yale University, 2016. | Includes bibliographical references.
Identifiers: LCCN 2016025556 | ISBN 9781933789071 (hardcover with slipcase, dust jacket : alk. paper)
Subjects: LCSH: Animals, Fossil--Arabian Peninsula. | Fossils--Arabian Peninsula. | Paleontology--Arabian Peninsula. | Arabian Peninsula--History.
Classification: LCC QE756.A73 B53 2016 | DDC 560.95357--dc23
LC record available at *https://lccn.loc.gov/2016025556*

ISBN: 978-193378907-1

This paper meets the requirements of ANSI/NISO Z39.48-1992 (Permanence of Paper).

10 9 8 7 6 5 4 3 2 1

CONTENTS

1	Introduction	60	Rodents
4	Geological Time	68	Birds
9	What Is a Fossil?	72	Reptiles
14	Paleoenvironments and the Baynunah River	78	Fish
18	Arabian Rivers	80	Snails and Mussels
22	Al Gharbia Landscapes	83	Insects
30	Elephants	86	Plants
44	Carnivores	90	Summary
48	Giraffes	94	Acknowledgments
50	Antelopes	96	A Brief History of Paleontological Exploration in Abu Dhabi
52	Horses	98	Further Reading
54	Hippopotamuses	103	The Authors
56	Pigs	105	Credits
58	Monkeys		

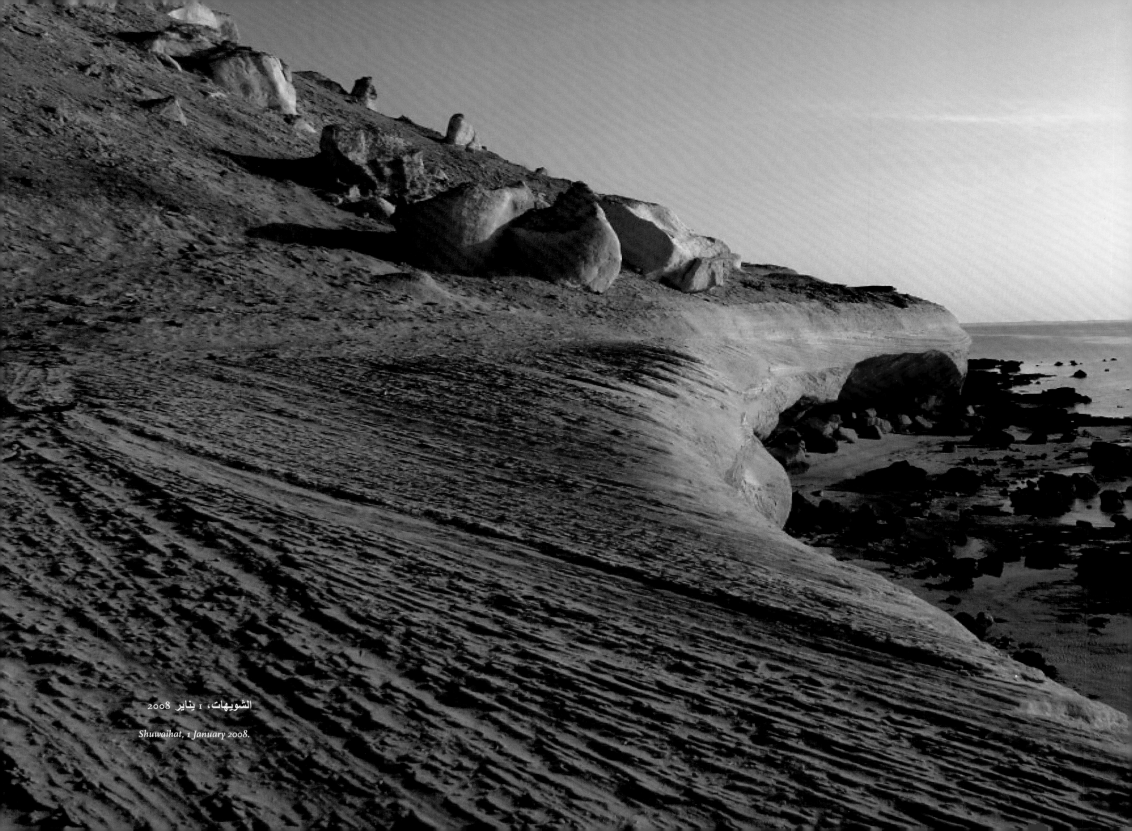

Shuwaihat, 1 January 2008.

Introduction

How can we know anything about animals that lived in the remote past, and about the environments they lived in? Once wild animals die they may be taken apart by carnivores, and ultimately rot and disappear entirely, but every now and again remains of long-dead animals are found that have been preserved over millions of years, giving us glimpses into past life. These fossils are very rare, particularly the remains of animals that lived on land.

An important occurrence of such fossils, however, has been found in the desert of Abu Dhabi Emirate. Mainly along the coast in Al Gharbia, in rocks named the Baynunah Formation, evidence of many animals has been found, including many that do not inhabit the region today, and it might perhaps be surprising if they did. They are animals now associated with different environments, such as elephants, hippos, antelopes, giraffes, pigs, monkeys, and numerous others. This is their story.

ملخص

يمتاز بعض متحجرات الحيوانات المكتشفة في تشكيل البينونة بأهمية كبرى، ليس في الإمارات فحسب، بل في الجزيرة العربية ككل وعالميا. وقد أثارت تلك الاكتشافا اهتماماً كبيراً لدى المعنيين بالبلاد وتاريخها، كما أن الاكتشافات استدرجت دائماً تغطية واسعة في وسائل الإعلام.

حيوانات البينونة هي المجموعة الوحيدة من مجموعات متحجرات الثدييات المعروفة في كل الجزيرة العربية التي تعود إلى ما بين 14 مليون عام ومليون عام خلت، التي توفر لنا الفرصة الوحيدة حتى نعرف ما كان يحدث في هذا الإقليم الواسع من العالم في زمن كانت فيه الحيوانات الثديية في العالم القديم في طور التطور والاتجاه نحو اكتساب أشكالها المعاصرة. ودائماً ما كانت الجزيرة العربية مهمة في مسار التطور هذا من حيث إنها تقع على مفترق تتقاطع عنده مناطق الحياة الجغرافية العظمى في العالم القديم في أفريقيا وآسيا وأوروبا، فضلاً عن أنها شكلت الممر الذي يمكن أن تكون تلك الحيوانات قد توسعت عبره من منطقة إلى أخرى. وقد مارست الجزيرة العربية وبيئاتها السالفة بعض التحكم بطبيعة الحيوانات الثديية في العالم القديم.

ولا تزال مواقع المتحجرات منتجة، والمرجو هو أن تتمتع بحمايةٍ كلية لأجيال المستقبل. ومن المهم أن يجري حفظ المجموعات في أماكن تتيح عرض بقايا الماضي هذه على الجمهور. وأن تشجع أيضاً البحث العلمي من أجل أن نعرف المزيد عنها وعما تخبرنا عن ماضي إمارة أبوظبي السحيق.

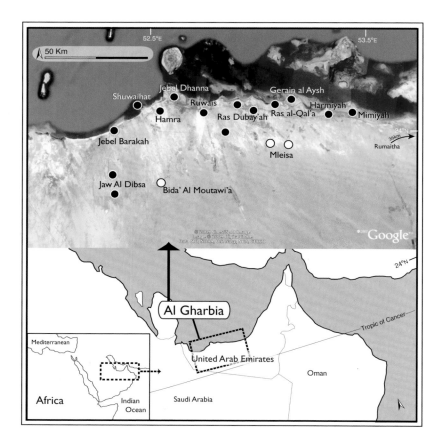

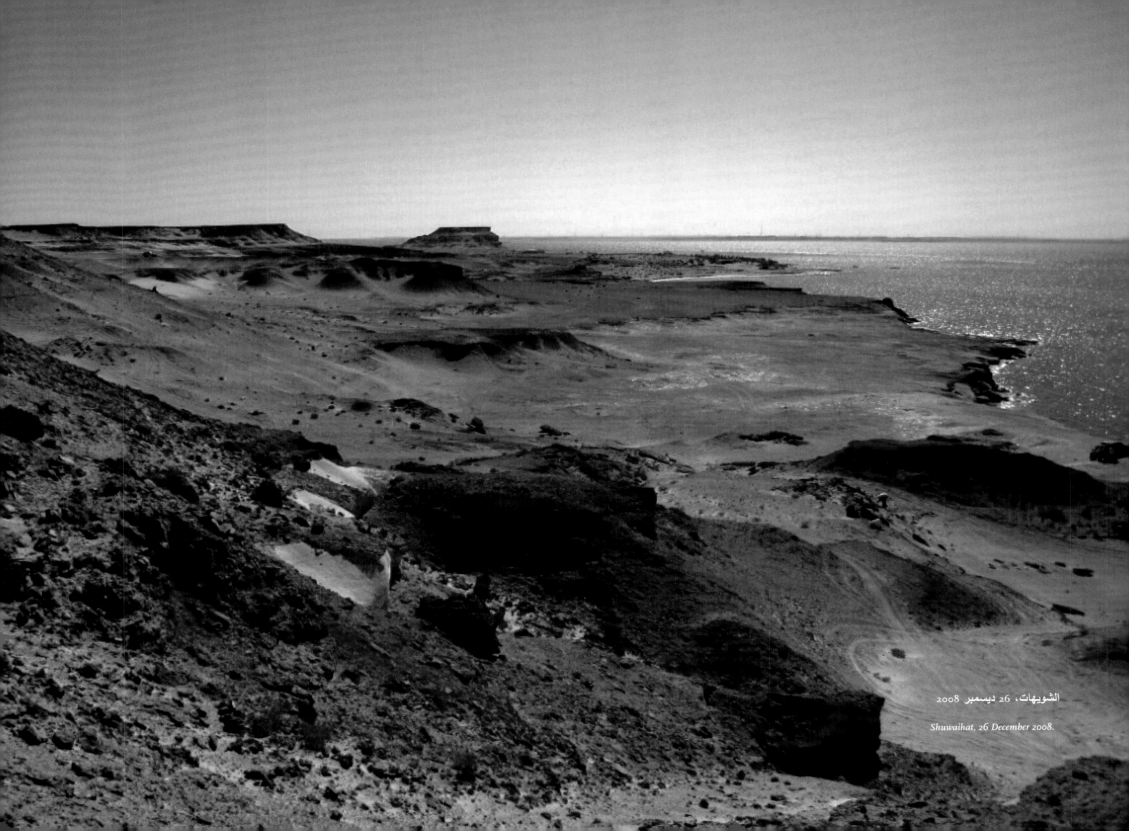

الشويهات، 26 ديسمبر 2008

Shuwaihat, 26 December 2008.

Geological Time

We now know that earth's history is very long. The age of the oldest rocks on earth has been estimated at around 5 billion years. The first life seemed to appear a little over 3.5 billion years ago, but it was not until around 200 million years ago that the first mammals came along. These creatures were unlike most of the modern mammals that we know today. Mammals really only began to flourish, evolve, and diversify once most dinosaurs became extinct at about 65 million years ago. The fossils of Al Gharbia provide us with information about the development of mammal communities—along with the fish, reptiles, birds, and other animals that lived alongside them—at a late stage in the development of the Old World fauna.

How can we know how old the fossils of Baynunah are, or how old any rock or fossil is? One technique is a radiometric method, mainly applicable to rocks of volcanic origin. When lavas or volcanic ashes erupt, crystals are formed that are laid down as part of the rock. Certain substances in them undergo radioactive decay into other materials at a known rate. Consequently they form a kind of clock, which can be read by very precise measurements of the relative amounts of different elements in these crystals. This makes it possible to estimate how much time has elapsed since the rock formed, and hence how old it is.

This is all very well if you are in a part of the world that has volcanic rocks. Unfortunately, none are known from Al Gharbia. Eastern Africa, however, particularly along the Great Rift Valley that cuts through that part of the continent, has been well supplied with volcanoes and fossil sites. Through work there over the past few decades, a very well-dated chronology of change in animal species through time has been developed by analyzing the dateable rocks that enclose the fossiliferous levels. Some of the same extinct animals occur in both East Africa and Abu Dhabi. For example, the Abu Dhabi fossil hippopotamus—*Archaeopotamus*—is very similar to those known from the fossil site of Lothagam in northern Kenya. Lothagam is well dated to between 7.5 and 6.5 million years. From knowing in this way the age of a variety of species that are common to Abu Dhabi and Africa, we can assume that the fossil sites in Al Gharbia are between around 6.5 million and 8 million years in age, but probably nearer to 6.5 million. This may seem a long time ago, and it

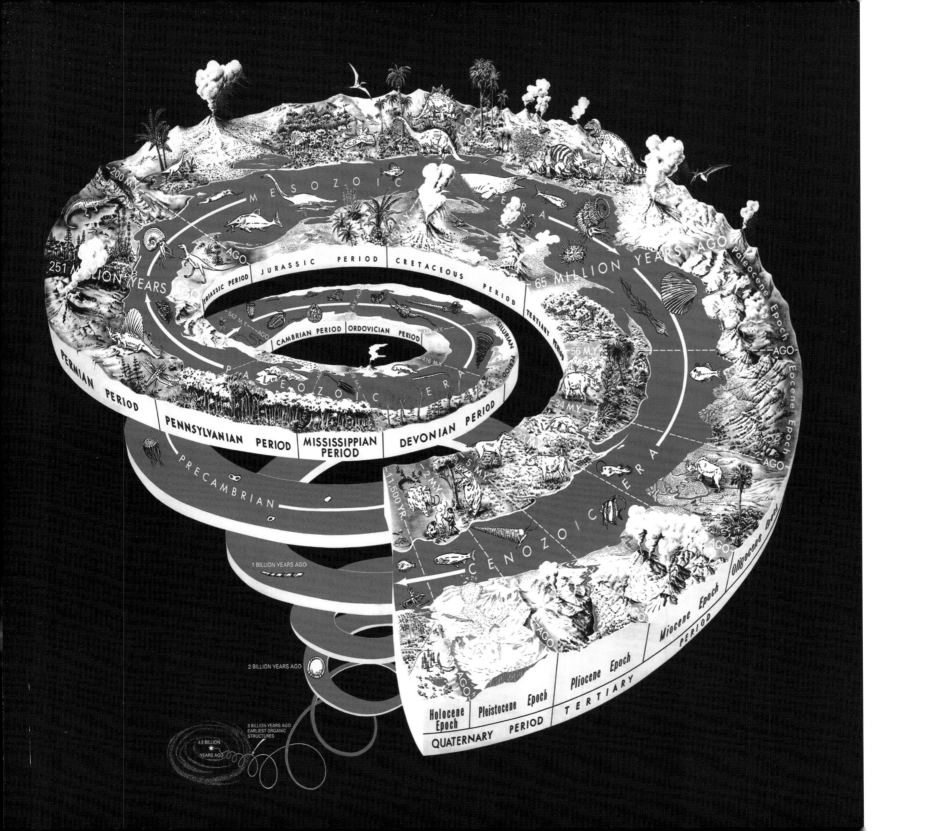

certainly is by the short lives of humans, but in terms of the long history of the earth it is quite recent. This time period is part of what is classified as the late Miocene Epoch of geological time, and it marks the origins of the modern Old World terrestrial fauna.

الفصائل التي انتشرت في أبوظبي يمكننا أن نفترض أن عمر مواقع الأحافير في الغربية يبلغ ما بين 6,5 و8 ملايين سنة، لكنه أقرب إلى 6,5 ملايين. وربما بدا أن هذه الأرقام تعود إلى زمن بعيد للغاية، وهو يقيناً كذلك إذا ما قيس بأعمار البشر القصيرة، أما بمقياس عمر الأرض الطويل فإنه تاريخ حديث. ويعود ذاك التاريخ إلى الحقبة الميُوسينية المتأخرة من الزمن الجيولوجي التي تسجل أصول حيوانات "العالم القديم" البرية.

الزمن الجيولوجي

نعلم اليوم أن تاريخ الأرض طويل للغاية، فقد جرى تقدير عمر أقدم الصخور على الأرض بحوالي 5 بلايين سنة. ويبدو أن أول حياة ظهرت قبل أكثر من 3,5 بلايين سنة بقليل، غير أن أولى الثدييات لم تتواجد إلا قبل نحو 200 مليون سنة. ولم تكن هذه الحيوانات مثل أي من الثدييات التي نعرف اليوم. في الواقع، لم تبدأ الثدييات بالازدهار والتطور والتنوع إلا بعد أن انقرض معظم الديناصورات قبل 65 مليون سنة. وتزوّدنا متحجرات البينونة، أو أحافيرها، بمعلومات عن تطور مجتمعات الثدييات – إلى جانب الأسماك والزواحف والطيور والحيوانات الأخرى التي تعايشت معها هناك، وذلك في مرحلة متأخرة من تطور عالم تلك الحيوانات القديم. ولكن، كيف يتسنى لنا أن نعرف عمر متحجرات البينونة أو عمر أي صخرة أو متحجرة أخرى؟

إحدى الطرق التقنية هي طريقة إشعاعية (راديومِثرية) تستخدم بشكل أساسي في الصخور ذات الأصل البركاني. فعندما تتفجر الحمم والرماد تتشكل بلورات تترسب وتصبح جزءاً من الصخرة. بعض أجزاء الترسبات هذه تمر بتحلل إشعاعي نشط لتصبح مواد أخرى بوتيرة معروفة. وهي بذلك تشكّل ساعةً من نوع ما تمكّن أدوات دقيقة من أن تقرأ الكميات النسبية من العناصر في تلك البلورات. وهذا يمكننا من أن نقدّر الزمن الذي انقضى منذ أن تشكّلت الصخرة، وبالتالي معرفة عمرها. كل هذا معقول في حال كنا في موقع من هذا العالم حيث توجد صخور بركانية. أما في الغربية، للأسف، فلا وجود لمثل هذه الصخور البركانية. بالمقابل، ثمة وفرة منها في مواقع المتحجرات البركانية في شرق أفريقيا، وخصوصاً على امتداد وادي الصدع الكبير الذي يخترق ذلك الجزء من القارة. وقد ساعد العمل هناك في العقود القليلة الماضية على إنتاج تسلسلٍ زمني جيد يُظهر التغييرات التي حصلت في فصائل الحيوانات عبر الزمن وذلك بفضل تحليل الصخور القابلة للتوقيت والتي تغلف المستويات المتحجرة، أو الأحفورية، التي تحتويها.

بعض من الحيوانات المنقرضة نجده في كلٍّ من شرق أفريقيا وأبو ظبي. على سبيل المثال، فإن متحجّرات فرس النهر الظبياني (أرْكيوبوتوموس) تشبه كثيراً المتحجرات المعروفة في موقع الأحافير في لوثاجام في شمال كينيا. فأحافير لوثاجام قد جرى توقيتها توقيتاً جيداً على أنها تعود إلى ما بين 7,5 و 6,5 ملايين سنة خلت. ومن خلال معرفة أعمار تنوعٍ من

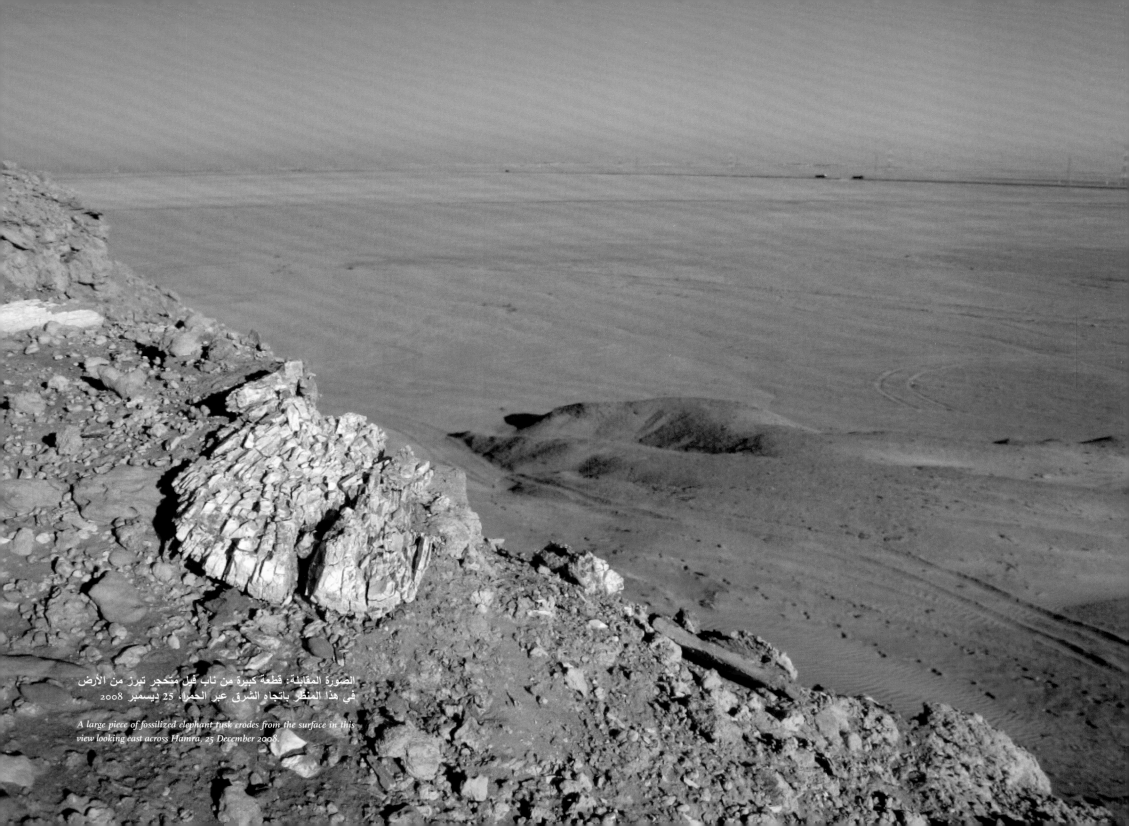

الصورة المقابلة: قطعة كبيرة من ناب فيل متحجر تبرز من الأرض في هذا المنظر باتجاه الشرق عبر الحمرا، 25 ديسمبر 2008

A large piece of fossilized elephant tusk erodes from the surface in this view looking east across Hamra, 25 December 2008.

What Is a Fossil?

Most people have an idea of what fossils are—shells perhaps, or teeth and bones, that have become solidified and preserved from a distant time in the past, buried in rock of some kind. In fact, a fossil is any remains of life that have been preserved from the past in rock. In the case of the Baynunah Formation, we have bones of mammals but also wood from trees, nests of insects, and trails of footprints made by elephants. All of these are fossils, and they give us some information about the lives of the animals and plants that made them.

Although we may be familiar with them, fossils are rare as compared with the numbers of animals that have existed, as it is only in uncommon circumstances that fossils are formed and persist over the millennia. This is for several reasons.

To begin with, the remains of most animals are quite quickly destroyed completely by any of a number of factors, particularly if they are just lying on the surface. If by chance the bones are buried and protected in some way, then they stand a better chance of long-term preservation. Occasionally animals become quickly covered by the sands, mud, and other sediments of rivers, lakes, or various marine environments. Sometimes they are protected from disturbances on the surface by being inside caves.

But just being buried is not enough. The remains have to be buried in a stable situation that will persist over a long time. It is no good for a bone to be buried if it is then to be exhumed by climatic forces and lost just a few years later. An additional problem is that even when buried, bones and other animal remains can still be destroyed by the action of water and chemicals permeating the sediments in which they are buried. Over time they simply dissolve and disappear.

Yet sometimes the environment is suitable for longer-term preservation. Bones or other remains are altered and preserved by chemicals in the ground and become "fossilized", that is, replaced by minerals that effectively change them into rock and make them more durable. The final piece of good fortune is then to be re-exposed on the surface. There they can be discovered and collected by paleontologists, who will further preserve them, study them, and curate them safely in suitable museums and research centers.

But this is a long series of fortuitous accidents, and there are long odds against an animal ending up as a fossil and ultimately being studied by scientists. It is fortunate that such a rich occurrence of fossils has been discovered in Abu Dhabi, which can provide useful information about the past of the Emirate and of Arabia as a whole.

إلى اليسار: العظام البيضاء المتحجرة في مقدم الصورة تعرّت مؤخراً بفعل انجراف أحدثه المطر والريح وهي تخرج إلى وجه الأرض. راس ضبيعة 15 ديسمبر 2007.

Left: The white fossilized bones in the foreground have been newly exposed by erosion (rain and wind) and are weathering out onto the surface. Ras Dubay'ah, 15 December 2007.

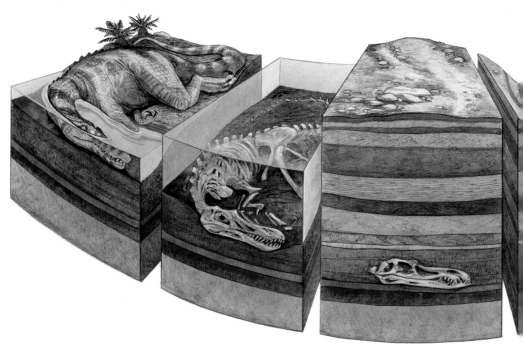

ما هو الأُحفور – أو المستحاثة؟

معظم الناس لديه فكرة عن الأحافير المتحجرة، كالأصداف والأسنان والعظام مثلاً، التي تصلّبت وحُفظت منذ ماضٍ بعيد، مدفونة في صخرة من نوع ما. والأحفور (من حَفَر) هو في الواقع أي بقية من بقايا الحياة المحفوظة منذ الماضي في الصخر. وهناك في موقع البينونة عظام ثدييات وكذلك خشبات من أشجار، وأعشاش حشرات، وآثار أقدام تركتها فيلة. كل هذه هي أحافير، أو مستحاثات متحجرة، تعطينا معلومات عن حياة الحيوانات والنباتات التي صنعتها (والمستحاث مِن استحثّ الشيء، أي غيّره وحضّه وحثّه).

وعلى الرغم من أنها باتت مألوفة لدينا، فالمتحجرات نادرة مقارنةً بأعداد الحيوانات التي وُجدت عبر الزمن، إذْ إن المتحجرات لا تتشكل ولا تُحفظ لآلاف السنين إلا في ظروف غير عادية. وهذا يعود إلى أسباب عدة.

بدايةً، فإن بقايا معظم الحيوانات تندثر بسرعة اندثاراً تاماً بفعل تأثير عدد من العوامل، خصوصاً حين تكون البقايا مكشوفة. أما إذا صودف أن دُفنت العظام أو حُميت بطريقة ما، فهذا يوفر لها فرصة الحفظ مدة طويلة. ويحدث أحياناً أن تغطي الحيوانات الرمالُ أو الوحلُ وغيرهما من رُسوبيات الأنهر أو البحيرات أو بيئات مائية مختلفة. وفي أحيان أخرى، فإن ما يحفظها من التقلبات هو وجودها في قلب المغاور.

إلا أن الدفن لا يكفي. فالبقايا يجب أن تكون مدفونةً في وضع مستقر يستمر زمناً طويلاً. فلا يجدي دفن العظمة إذا ما أعادت قوى مناخية نبشها فتضيع في بضع سنوات. المشكلة الأخرى هي أنه حتى لو دُفنت العظام فقد تتلف بفعل الماء والمواد الكيميائية التي تتخلل الرسوبات المدفونة فيها، إذ إنها، ببساطة، تذوب وتختفي بمضي الزمن.

بالمقابل، نجد أحياناً أن البيئة ملائمة لحفظ البقايا لزمن مديد. فالمواد الكيميائية في التربة تعمل على تغييرها وبالتالي حفظها إذ "تتحجر"، أي أنه يجري استبدالها بمواد غير عضوية تحوّلها إلى صخر وتجعلها أكثر ديمومة. أما البقايا المحفوظة فهي تلك التي تعود فتتكشف على السطح حيث يكتشفها علماء الأحافير، أو المستحاثات، الذين يعملون على متابعة حفظها، ودراستها وتأمينها في المتاحف ومراكز البحث الملائمة.

ولكن ذلك يتألف من سلسلة من المصادفات السعيدة إذ ترجّح ظروف كثيرة ألا ينتهي المطاف بحيوان إلى أن يتحجر وأن يدرسه علماء. وشاء الحظ الطيب أن يجري اكتشاف هذا التواجد الغني من المتحجرات في أبوظبي، الأمر الذي يوفر معلومات مفيدة عن ماضي الإمارات وشبه الجزيرة العربية ككل.

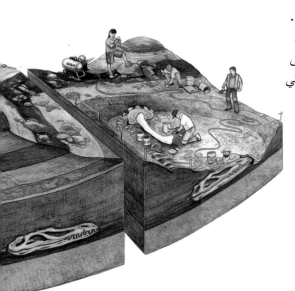

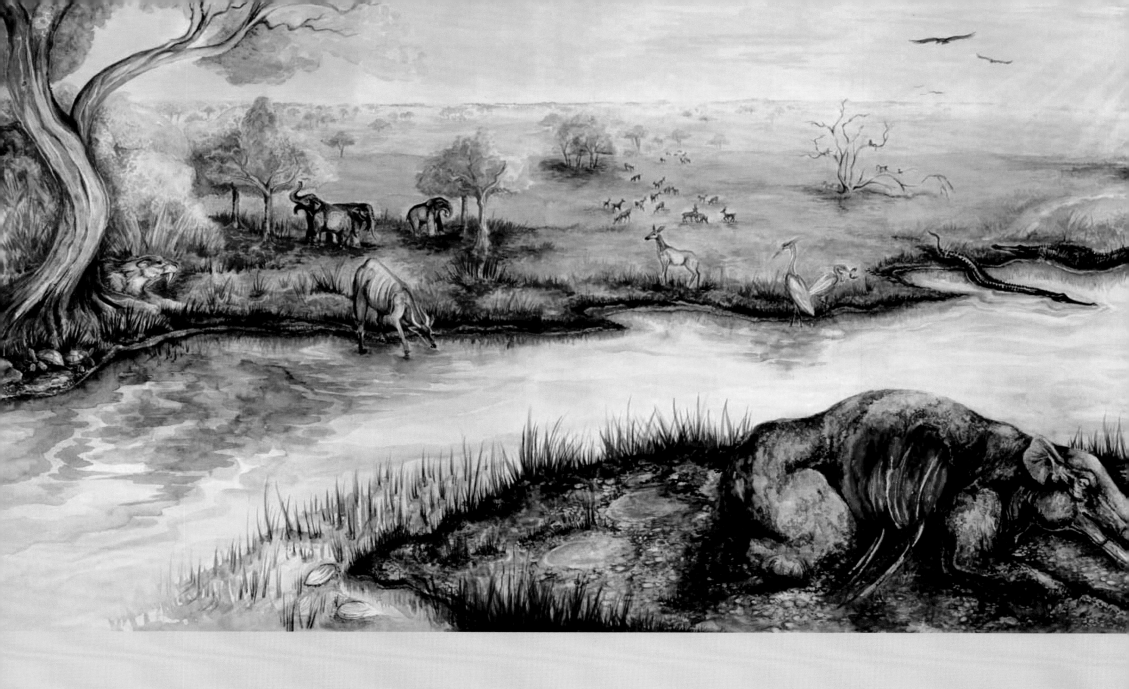

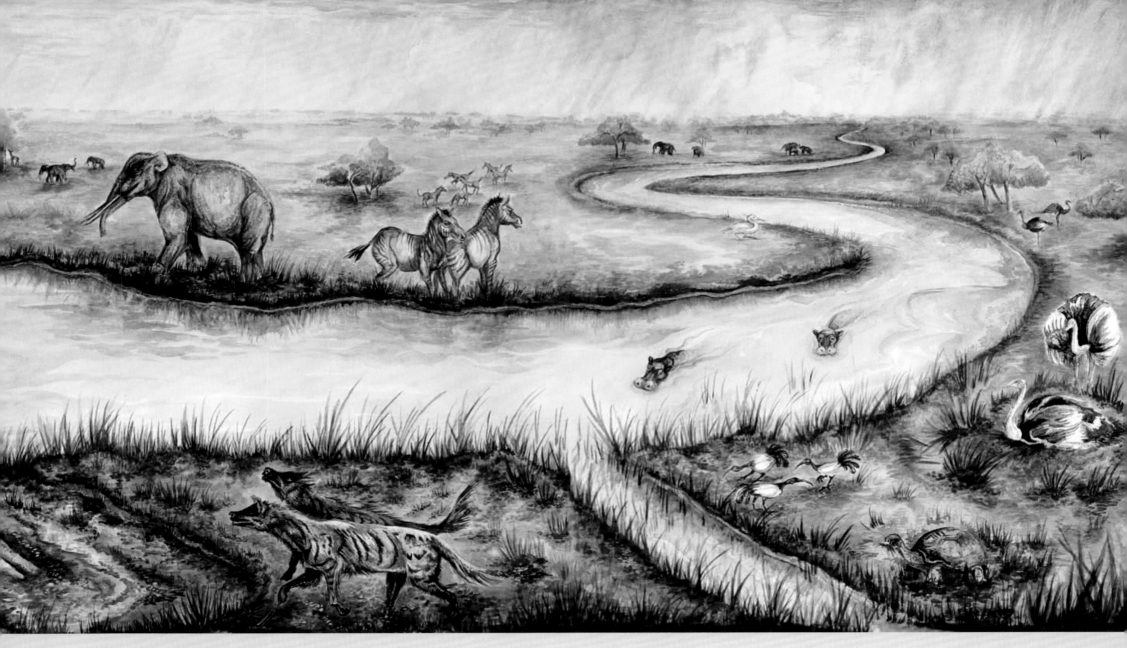

نهر البينونة وحيواناته كما تخيلها الرسام.

Artist's reconstruction of the Baynunah River and fauna.

Paleoenvironments and the Baynunah River

Today, the area that all these extinct animals inhabited some 7 million years ago is a desert almost devoid of natural vegetation, where fresh water is sparse—an environment unlikely to be able to support such an abundant diversity of animal life. It is tempting to imagine this abundance of mammals in the past, particularly the large ones, as signifying some major change in climate and conditions since then. That view would hold that in the past it was a land of profusion and plenty, with a luxuriance of vegetation and animal life, but that since then aridity intervened and the fauna dwindled. Some aspects of this supposition are obviously true, but not entirely.

Clearly there must have been enough water and vegetation to support herds of quite large mammals—antelopes, giraffes, horses, and such bulky beasts as elephants. But the availability of water may not have been a problem, because there is geological evidence of a large river flowing through the region in Baynunah times. The picture that emerges from studying the nature of the rocks is of a large river system—possibly part of an ancestral Tigris–Euphrates—flowing from a western source towards the east-southeast. There was no marine Gulf then. With the possible exception of a fossil sawfish, there is no sign of any marine influence, and indeed at the time the nearest sea could have been a good distance away, possibly beyond the present Strait of Hormuz.

Geological investigations suggest that the river system was composed of several channels 2 to 10 meters deep, separated by sand bars 2 to 5 meters high. The evidence of animals that lived in this river reinforce this view. The crocodiles, particularly the gavials, would have required constantly flowing, large, deep bodies of water; and although catfish can withstand periods of drought, other fish found as fossils belong to groups that are mostly bottom dwellers in slow, persistently moving water.

Among the few fossil plants available from the Baynunah Formation are fragments of fossil trees. At least one specimen has a preserved trunk of large diameter, implying a considerable height in life. It is also possible to get information about past vegetation by analyzing the carbon isotopes from nodules in fossil soils and from tooth enamel of plant-eating animals. The ratio of carbon isotopes preserved in fossil soil nodules reflects the nature of the vegetation at the time, whether the environment is a closed, wooded habitat

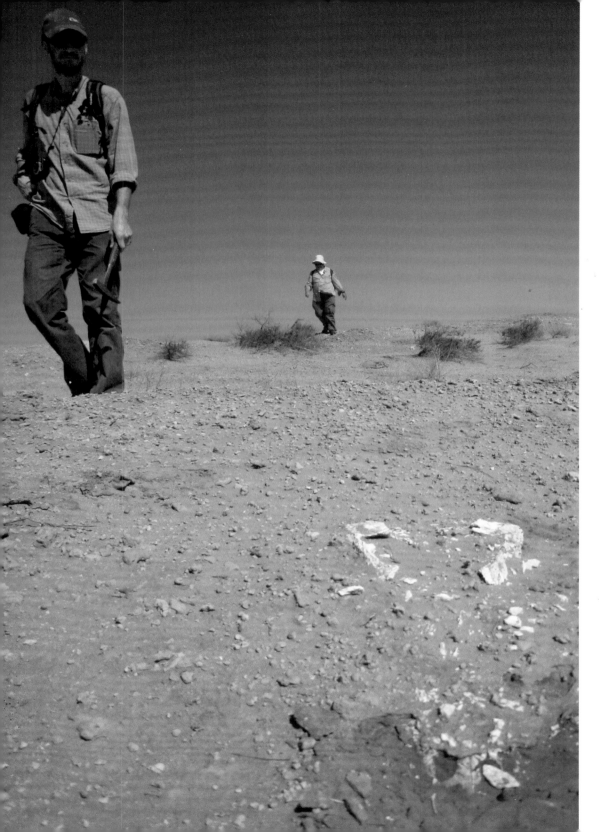

or open grassland. The same information from the tooth enamel of plant-eating animals indicates whether these herbivores were browsers or grazers, eating leafy vegetation or grass.

Our research suggests a grassy woodland near the river channels, with more open grasslands farther away from the water. At the same time there is evidence of dry habitats in the Baynunah rock succession. This implies that a lush woodland habitat was maintained by the constantly flowing, very large river, which graded off into grassland farther from its influence, and then arid conditions farther away still. So general conditions need not have been very different from the present day, but for the influence of the large river providing a habitat along its banks that the large mammals would have found quite congenial, perhaps like some parts of the Nile River today.

جبل براكه، 5 ديسمبر 2006.
جمجمة تمساح متكسرة تتعرى من التربة. الحدوانية، 12 يناير 2010.

Top: Jebel Barakah, 5 December 2006.
Left: A fragmented crocodile skull erodes to the surface. Hadwaniyya, 12 January 2010.

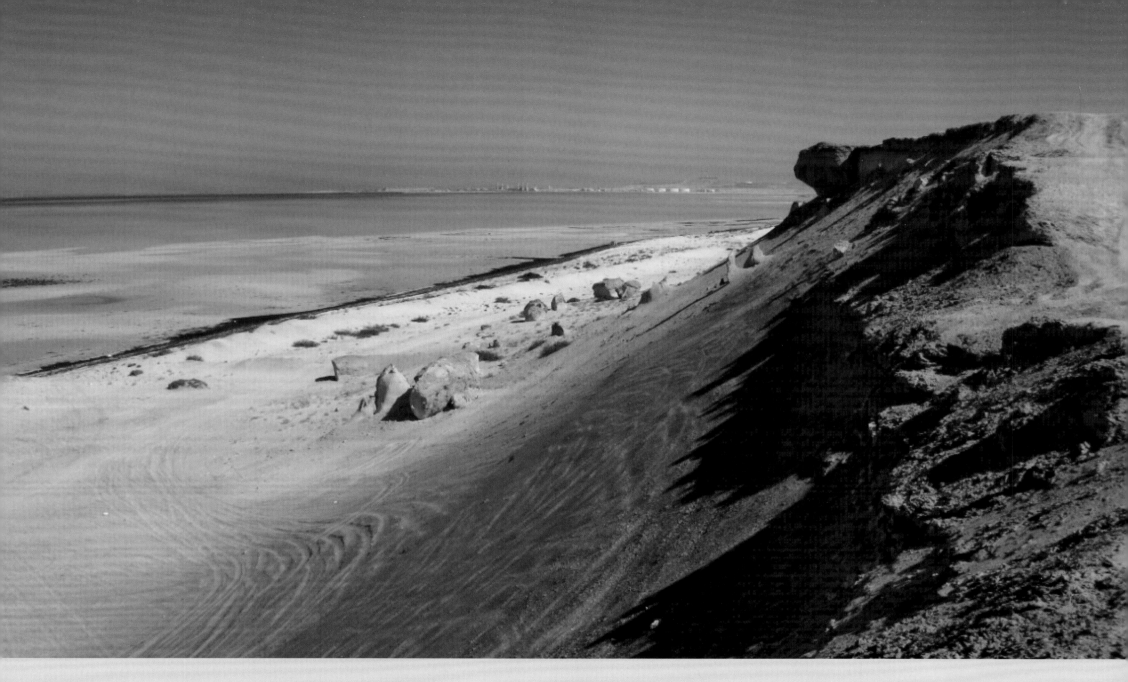

رمال البينونة تتلاقى اليوم ورمال بحر الخليج. الحمرا، 22 ديسمبر 2008.

Today the sands of the Baynunah River meet those of the Gulf sea. Hamra, 22 December 2008.

البيئات المتحجرة ونهر البينونة

المناطق التي سكنتها كل الحيوانات المنقرضة هذه قبل نحو سبعة ملايين سنة هي اليوم صحراء تكاد تخلو من أي حياة نباتية، ومكان تندر فيه المياه العذبة. إنها بيئة لا يُحتَمَل أن تدعم ذاك التنوع من الحياة الحيوانية. من المغري تصوّر تلك الكثرة من الثدييات في الماضي، وخصوصاً الثدييات الضخمة منها، من حيث أن ذلك يدل على حدوث تغير أساسي في المناخ والظروف منذ ذاك الزمن. ويُظهر هذا التصور أن تلك الأرض كانت أرض غزارة ووفرة في الحياة النباتية والحيوانية إلا أن القحل تدخّل بعد ذلك وتضاءلت أعداد حيوانات تلك الحقبة. من الواضح أن بعض جوانب هذه الفرضية صحيح، ولكن ليس تماماً!

يتضح اليوم إلى حدٍ بعيد أنه كان هناك ما يكفي من الماء والنباتات لإطعام قطعان من الثدييات الكبيرة كالبقريات والزرافات والخيول والحيوانات الضخمة، كالفيلة، مثلاً. لم يكن الماء مشكلة لأن هناك دليلاً جيولوجياً على وجود نهر كبير كان يخترق المنطقة في ذلك العصر. والصورة التي تظهر جراء دراسة طبيعة الصخور تبيّن وجود منظومة نهرية واسعة يمكن أن تكون جزءاً من منظومة دجلة – الفرات السالفة التي كانت تتدفق من مصدر غربي باتجاه الشرق والجنوب الشرقي. ولم يكن هناك خليج بحري وقتها. وربما باستثناء متحجرة تعود إلى سمك المنشار فلا يوجد ما يشير إلى تأثير بحري، بل إن البحر، في الواقع، كان يمكن أن يكون وقتها على مسافة بعيدة من موقع البينونة الحالي بل ربما أبعد حتى من مضيق هرمز الحاضر. وتشير الدراسات الجيولوجية إلى أن المنظومة النهرية تألفت من قنوات عدة تراوحت أعماقها بين مترين وعشرة أمتار. وكان يفصل بينها حواجز رملية بارتفاع مترين إلى خمسة أمتار. وأدلة الحيوانات التي عاشت في النهر تعزز هذا التصور. فالتماسيح، وخصوصاً تمساح الغريال (التمساح الهندي) منها، كانت تتطلب وجود كتلٍ هائلة من المياه العميقة المتدفقة باستمرار. ورغم أن سمك القط العذبة يمكنه أن يتحمل فترات من الجفاف فإن أنواع السمك المتحجرة الأخرى التي وجدت هنا كانت تنتمي إلى مجموعات يعيش معظمها في قعر مياه تتحرك ببطء ثابت.

وكان بين النباتات المتحجرة التي وجدت بكثرة في تشكيل البينونة أشجارٌ متحجرة كان جذع إحداها المحفوظ ذا قطر كبير، الأمر الذي يشير إلى أنها كانت في حياتها شجرة عالية علواً كبيراً. ومن الممكن أيضاً الحصول على معلومات عن النباتات الماضية من خلال تحليل نظائر الكربون المحفوظة في العُقد في التربة المتحجرة وفي مينا أسنان الحيوانات آكلات العشب. ونسبة نظائر الكربون المحفوظة في العُقد المحفوظة في التربة المتحجرة تعكس طبيعة الحياة النباتية في ذاك الزمن وتشير إلى ما إذا كانت البيئة حينها مغلقة أم حرشية أم حشائشية مفتوحة. والمعلومات نفسها المستقاة من مينا أسنان الحيوانات آكلة الأعشاب تدل على ما إذا كانت الحيوانات تأكل الأوراق أم الحشائش.

ويشير بحثنا إلى وجود أرض حرشية حشائشية بالقرب من أقنية النهر ووجود مزيدٍ من الأراضي الحشائشية المفتوحة على مبعدة من الماء. وفي الوقت نفسه هناك أدلة على وجود بيئات جافة في سلسلة صخور البينونة. ويشير ذلك ضمناً إلى وجود بيئة حرشية غنية يغذّيها نهر كبير للغاية يتدفق بثبات ويتفرع باتجاه أراضٍ حشائشية أبعد تتلوها ظروف قاحلة في مناطق أبعد فأبعد. لهذا فالظروف العامة السائدة حينها لم تكن بالضرورة مختلفة كثيراً عن ظروف اليوم فيما خلا تأثير النهر الكبير الذي يوفر مناطق سكن على ضفافه يمكن أن تكون الثدييات الكبيرة وجدتها ملائمة تماماً لحاجاتها، ربما في ما يشبه بعض أجزاء نهر النيل اليوم.

Arabian Rivers

The idea of a very large river flowing through what is now the desert of western Abu Dhabi may at first seem surprising, but it is just one example of a phenomenon that has been repeated at various times in the past. Arabia is intersected by old river systems that are evidence of wetter times. These occurred until the end of the Holocene Climatic Optimum, one of the most recent wet periods, which lasted from around 9000 to 6000 years ago. The current major phase of hyper-aridity dates back to the end of that period.

In the last couple of decades, imaging radar aboard NASA space shuttles has revealed the existence and courses of such major ancient river systems, which are now buried beneath the desert sands of the Arabian Peninsula.

الصورة المقابلة: وديان أنهر الجزيرة العربية الجافة. ١. وادي السرحان. ٢. وادي الحمد. ٣. الفرات ووديان تصب في حوض الفرات ٤. وادي الباطن. ٥. وادي سحبا. ٦. وادي الدواسر. ٧. وادي حضرموت.

Opposite page: The dry river valleys of the Arabian Peninsula. (1) Wadi as Sirhan, (2) Wadi al Hamd, (3) Euphrates and valleys draining into the Euphrates basin, (4) Wadi al Batin, (5) Wadi Sahba, (6) Wadi ad Dawasir, (7) Wadi Hadramawt.

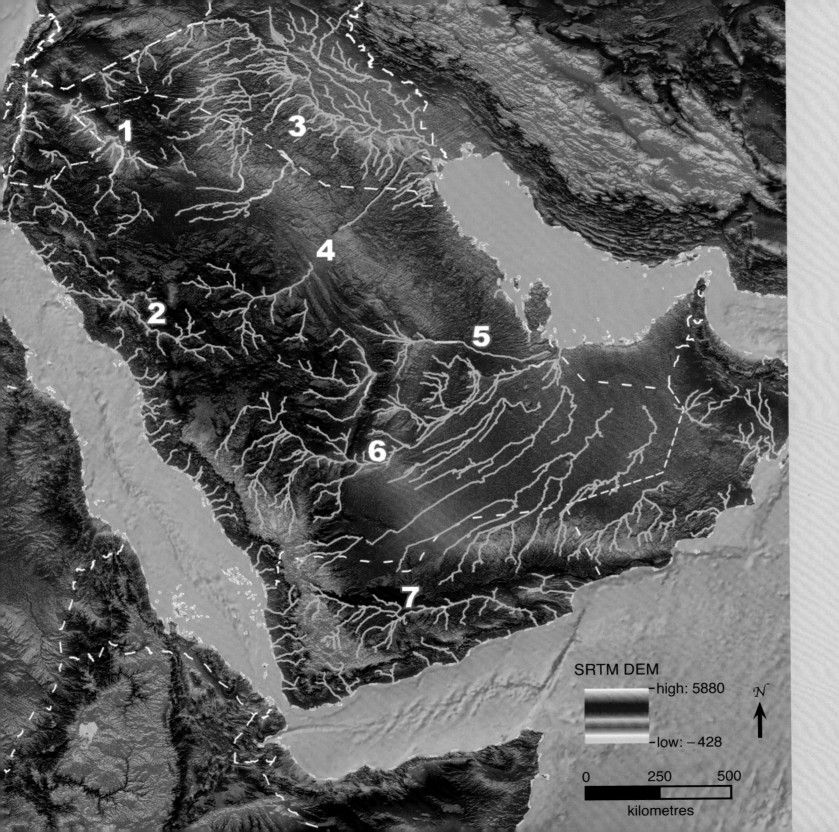

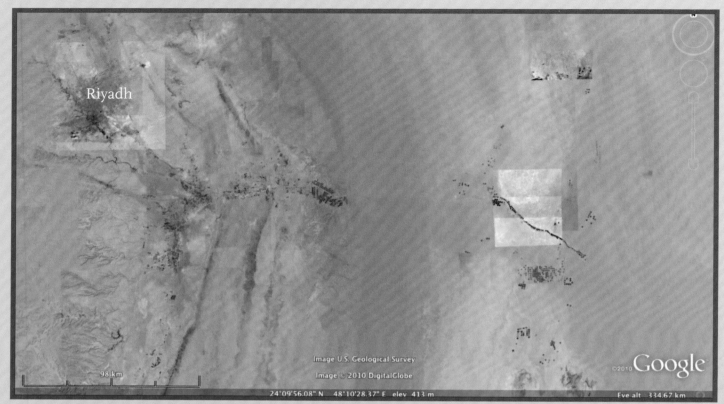

الأنهر العربية

للوهلة الأولى، قد تبدو غريبة تلك الفكرة التي تقول بوجود نهر كبير يتدفق عبر ما هو اليوم صحراء أبوظبي، إلا أن هذا لا يتعدى أن يكون مجرد مثال واحد على ظاهرة تكررت مرات عدة في الماضي. فالجزيرة العربية تتقاطع فيها نظم أنهرٍ قديمة دلالةً على أزمان أكثر رطوبة. وقد استمر ذلك حتى نهاية ذروة المرحلة المناخية الهولوسسينية (الحديثة) وهي واحدة من أحدث المراحل الرطبة التي استمرت من حوالى 9000 وحتى 6000 سنة خلت. وتعود مرحلة القحول القصوى الراهنة إلى أواخر تلك المرحلة.

في العقدين السالفين، أظهرت الصور الرادارية التي التقطها مكوك وكالة «ناسا» وجود نظم النهر الغابر هذا ومساربه التي باتت اليوم مطمورة تحت رمال شبه الجزيرة العربية.

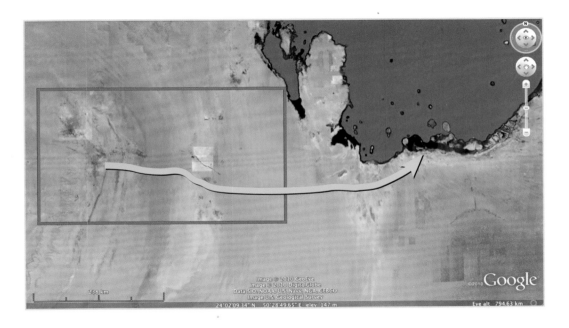

وادي سحبا هو مصدر محتمل لنهر البينونة. ويمكن أن تُظهر صور القمر الصناعي (بالزار) وديان الأنهر الجافة التي تغطيها الصحراء اليوم.

Opposite page and above: The Wadi Sahba is one possible source of the Baynunah River. Satellite imagery (PALSAR) can reveal dry river valleys that are today covered by desert sands.

Al Gharbia Landscapes

Much of the landscape along the coast in Al Gharbia is characterized by coastal *sabkha*. These are extensive low-lying salt flats that are maintained by periodic inundations of rain water or marine storm surge. The surface is often broken up into a pattern of large polygons formed through evaporation and aridity, and is characterized by crusts of the salts that form there.

Between these low-lying areas, however, are upstanding flat-topped hills or *mesas*. These are the eroded remnants of rocks that were laid down in the large Miocene river system—which have been named the Baynunah Formation—and are now eroding slowly away. It is in these rocks that the fossils are found.

Such hills are less prominent inland, where sandy desert and dunes supervene. But the same rocks at some points form the floor of the desert there, and fossils are also to be found up to 30 kilometers inland. It is in this inland area, for example, that elephant fossil footprints have been discovered.

الصورة المقابلة: قرب أم الكبير، 9 ديسمبر 2006.

Opposite page: Near Umm al Kabir, 9 December 2006.

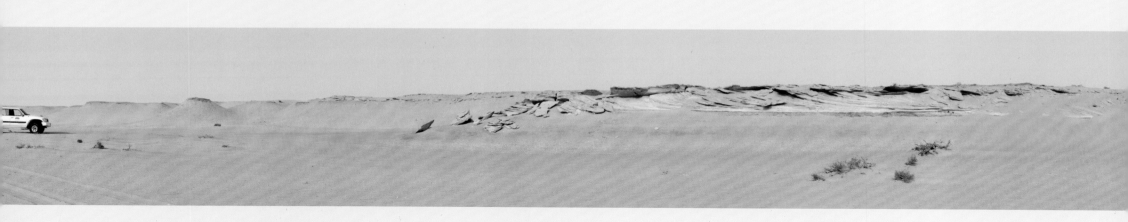

Ice age desert dunes lie on top of the much older Baynunah River sediments. Umm al-Kabir, 8 January 2011.

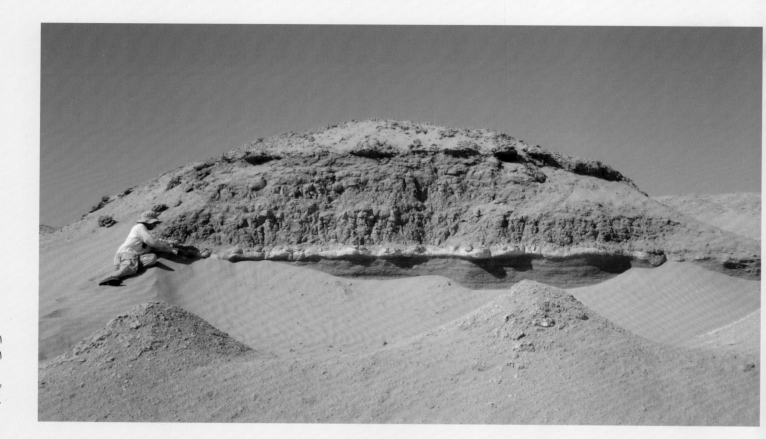

الطبقات المختلفة التلوين من ترسبات البينونة يمكن أن يقرأها الجيولوجيون كما تُقرأ صفحات الكتاب. جبل براكه، 5 ديسمبر 2006.

The different-colored layers of the Baynunah Formation may be read by geologists like the pages of a history book. Jebel Barakah, 5 December 2006.

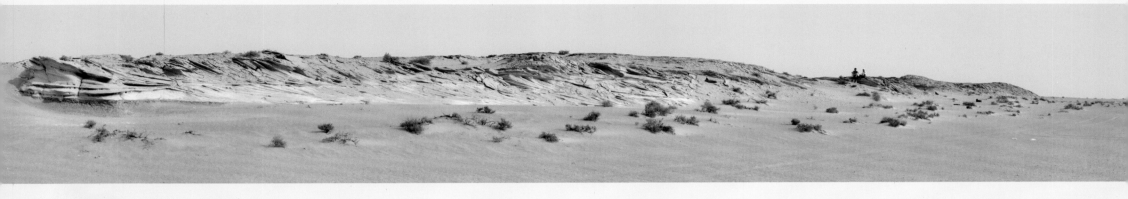

كثبان رملية من العصر الجليدي التي تقع على قمة ترسبات نهر البينونة الأقدم بكثير. موقع أم الكبير، 8 يناير 2011.

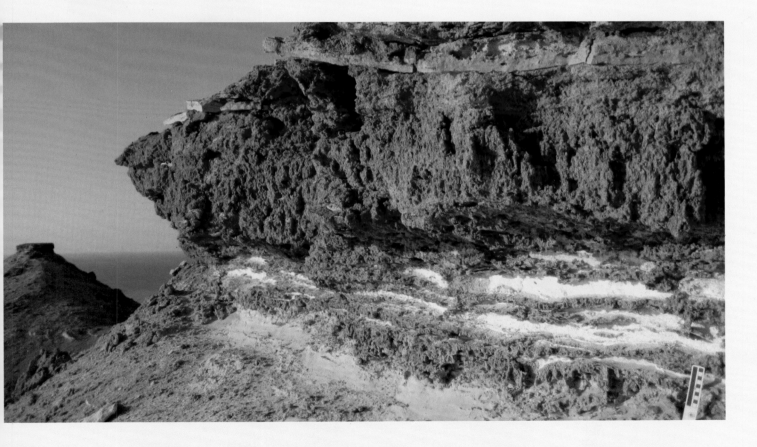

طبقة من حجر الكلس الصلب والجبس تغطي مناطق مكشوفة كثيرة من ترسبات نهر البينونة، ما يضفي عليها شكل سطح الطاولة. الشويهات، 21 ديسمبر 2007.

A layer of hard limestone and gypsum caps many exposures of the Baynunah River sediments, giving them a table-top appearance. Shuwaihat, 21 December 2007.

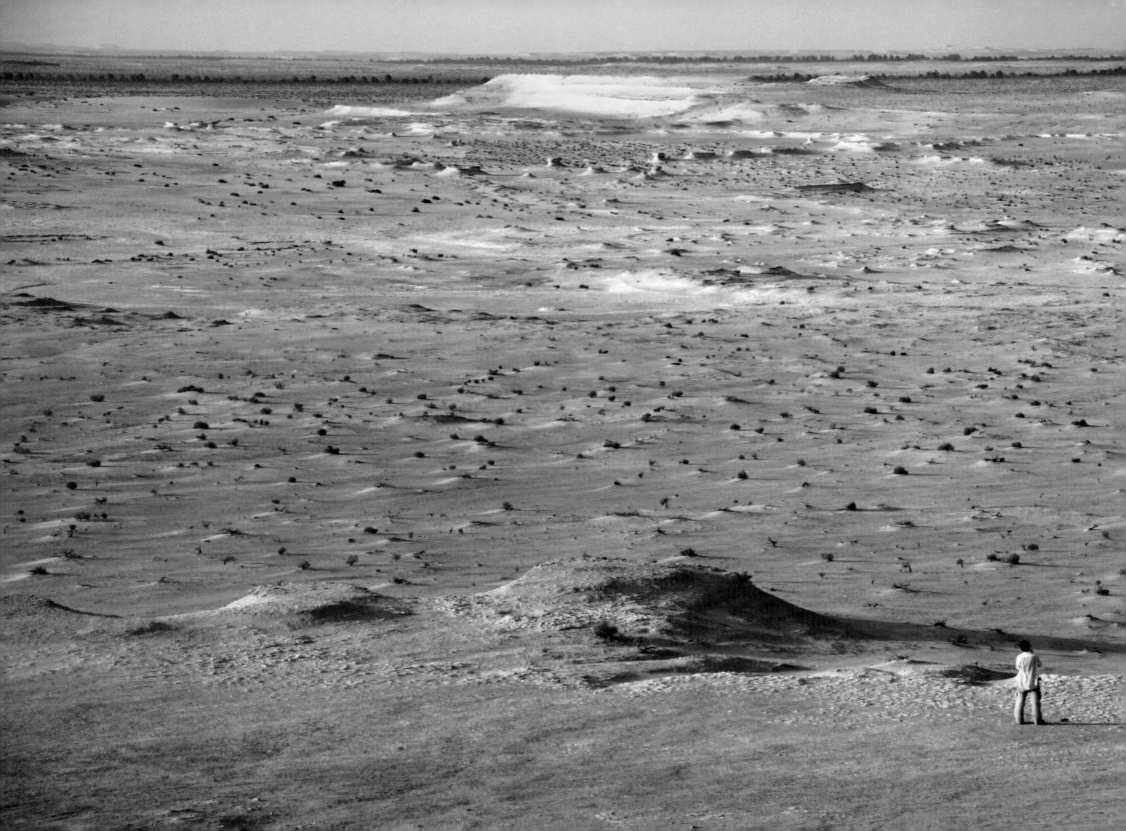

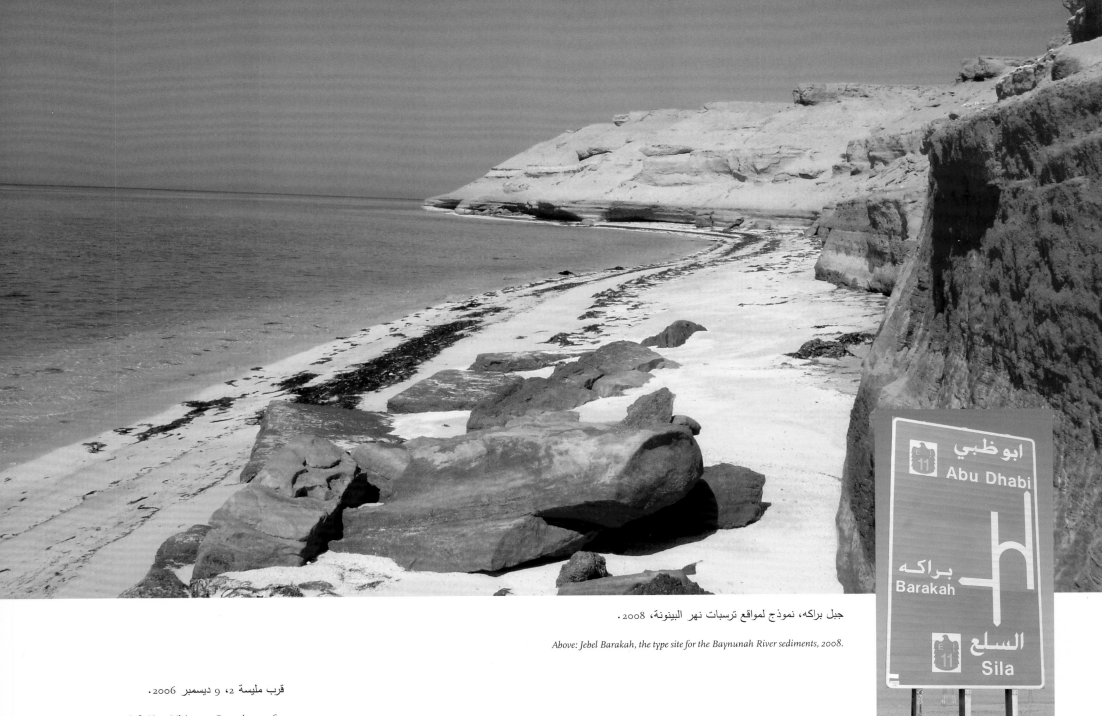

جبل براكه، نموذج لمواقع ترسبات نهر البينونة، 2008.

Above: Jebel Barakah, the type site for the Baynunah River sediments, 2008.

قرب مليسة 2، 9 ديسمبر 2006.

Left: Near Mleisa 2, 9 December 2006.

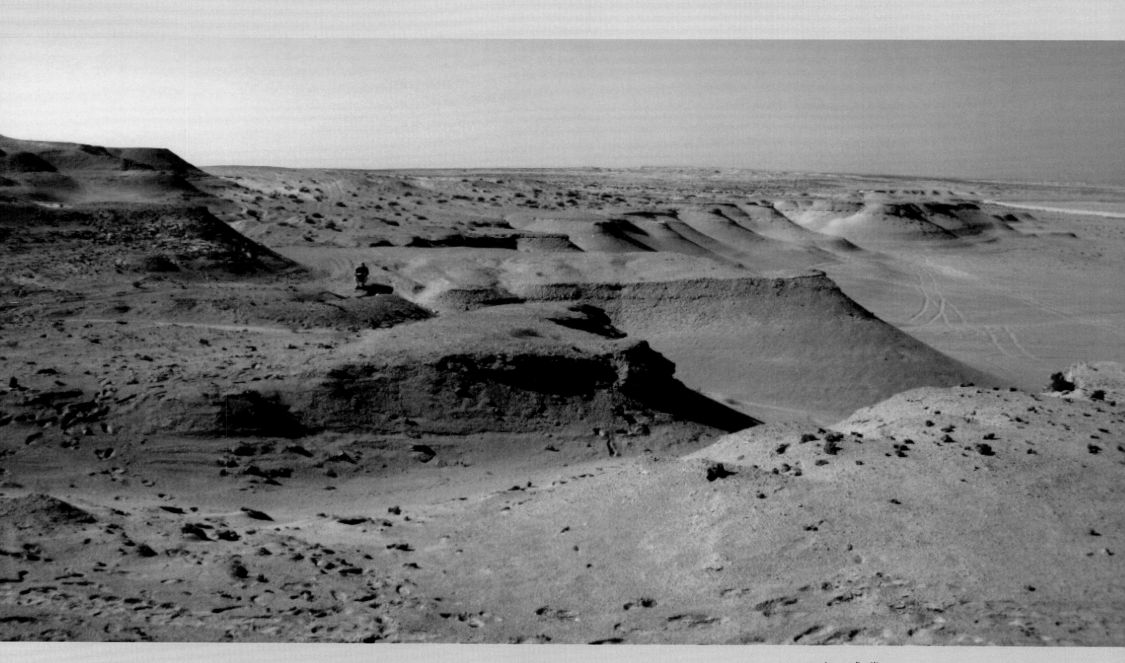

الكحال، ١ يناير ٢٠٠٩.

Kihal, 1 January 2009.

طبيعة منطقة الغربية

الحضوانية، 11 يناير 2010.

Hadwaniya, 11 January 2010.

يتكون جزء كبير من منطقة ساحل الغربية من سبخات ساحلية. وهذه أراض ملحية منبسطة ومنخفضة تستمر بفضل موجات مُغرقة من مياه الأمطار أو موجات من العواصف البحرية. وكثيراً ما تتقطع الأرض هناك إلى نمط من الأشكال متعددة الأضلاع والتي تتشكل جراء التبخر والقحل وتتميز بقشرة من الملح.

غير أن تلالاً، أو «ميسات» (هضاب مستوية متحدرة الجوانب) تبرز ما بين تلك المساحات المنخفضة. والميسات هي بقايا صخور استقرت في نظام النهر الميوسيني، وهي التي سُميت «تشكيل البينونة».

تتواجد مثل هذه التلال بشكل أقل في الداخل حيث الصحراء والكثبان الرملية. إلا أن الصخور ذاتها تشكل أرضية الصحراء هناك، ويمكن إيجاد متحجرات على بعد قد يصل إلى 30 كيلومتراً. هنا، في هذه المنطقة الداخلية، مثلاً، جرى اكتشاف آثار أقدام فيلة.

Elephants

Some of the largest and most prominent fossils from Abu Dhabi are from elephants. The modern African elephant (*Loxodonta africana*) is the largest living land animal. Beasts similar to elephants have been around in the past for a long time, but one of the fossil species found in the Baynunah Formation (*Stegotetrabeledon syrticus*) is one of the first of the modern kind of elephant, belonging to the zoological family Elephantidae. It has tusks not only in its upper jaw, as do modern elephants, but in the lower jaw as well. Another fossil species from the Baynunah is a more primitive form, probably belonging to the genus *Amebelodon*. And a possible third kind, known only from a fragment of tooth, belongs to a group of widespread and curious animals, the deinotheres, which were characterized by distinctive downturned tusks in the lower jaw.

Unusual fossils associated with *Stegotetrabelodon*—by far the most common fossil elephant in Abu Dhabi—enable us to know much more about it and its life than we do about other species, including details of its social structure. Both species of contemporary elephant, the African and the Indian

الصورة المقابلة: هكذا تصوّر الفنان فيلة أبو ظبي المتحجرة استناداً إلى موقع مليسة 1 العجيب، حيث حُفظت مسارات من آثار أقدام الفيلة التي كانت تمشي معاً، بما في ذلك آثار فيل صغير.

Opposite page: An artist's reconstruction of the fossil elephants of Abu Dhabi, based on the remarkable site of Mleisa which preserves trackways of many prehistoric elephants walking together, including a young individual.

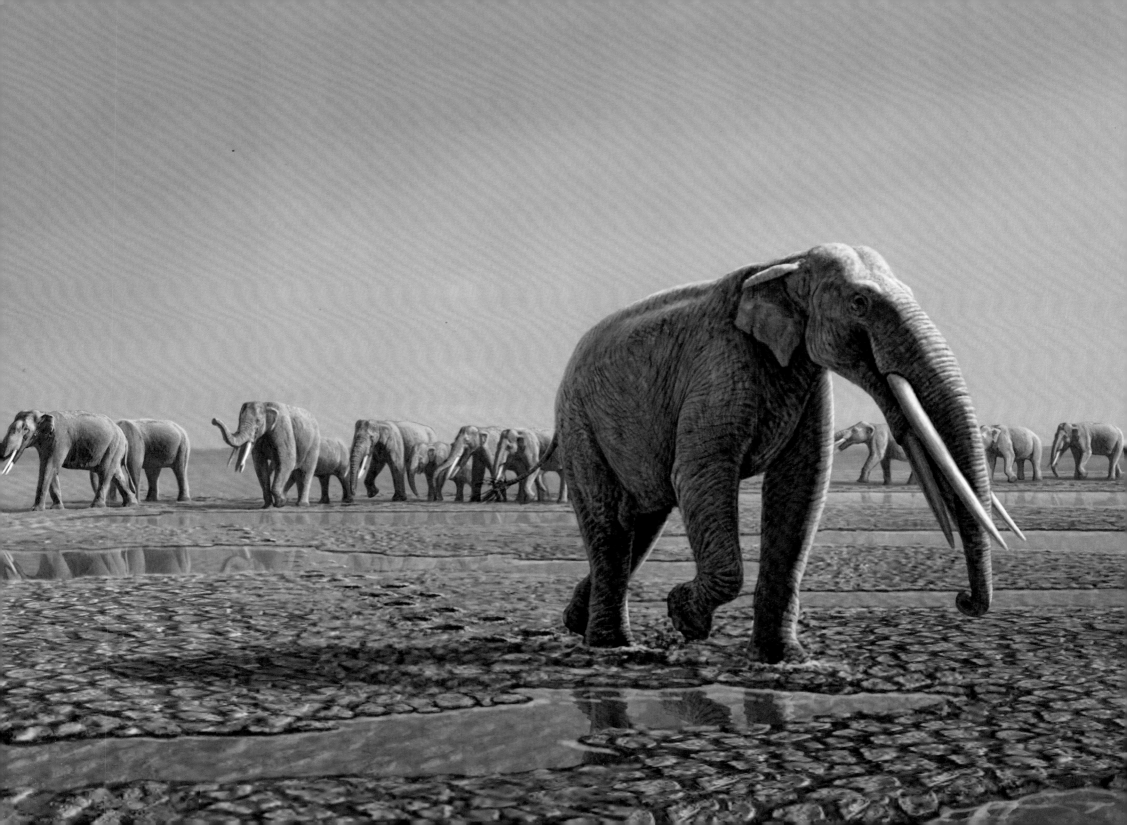

(*Elephas maximus*), live in social groups, where a matriarch leads a herd composed of mostly between ten to twenty female adult relatives and young offspring. Young males leave the herd at maturity and lead quite solitary lives, returning to female dominated groups intermittently for social interactions and mating.

Knowing the social structure of extinct animals is of course extremely difficult, as we can no longer observe them directly, but sometimes a situation presents itself that makes such a thing possible. This was the case with a remarkable set of fossils in Abu Dhabi.

They consist of a number of very extensive trackways of footprints, inland in the desert near Mleisa and at a couple of other locations and were shown to us by Mubarak al Mansouri, an Emirati who knew the local area well. The huge footprints have clearly been made by elephants, and some tracks extend for nearly 270 meters. They were so large and widespread that it was at first difficult to appreciate them properly. But then we encountered Nathan Craig, an archaeologist who takes aerial photographs from kites. He flew his kite over the exposures, taking hundreds of pictures

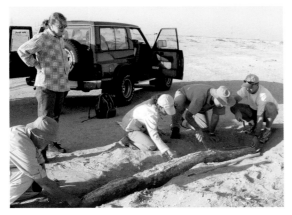

استخراج ناب فيل طوله متران. الرويس، 2003.

Above: Excavating a 2-meter long elephant tusk at Ruwais, 2003.

بقايا ناب فيل متآكل. الحمرا، 24 ديسمبر 2008.

Right: Remains of an eroded fossil tusk. Hamra, 24 December 2008.

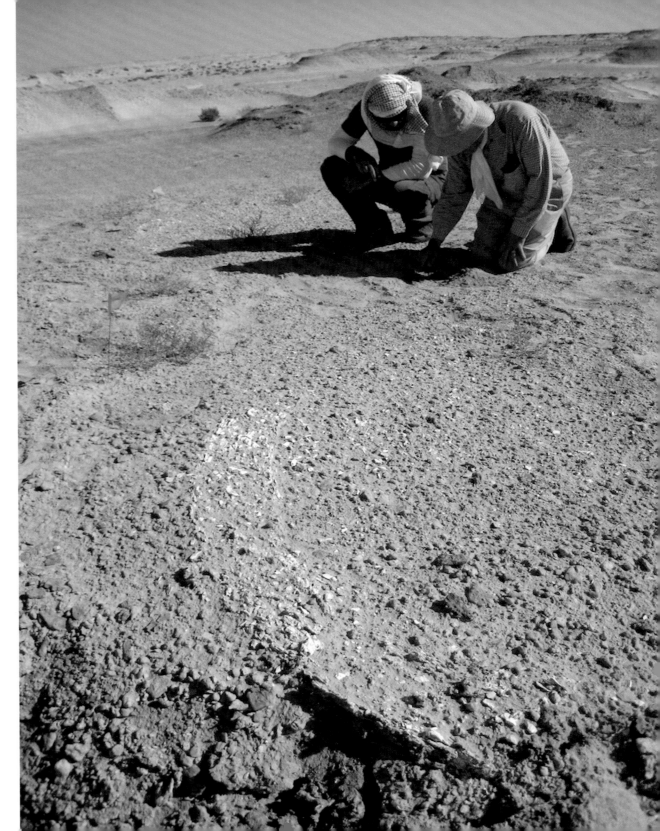

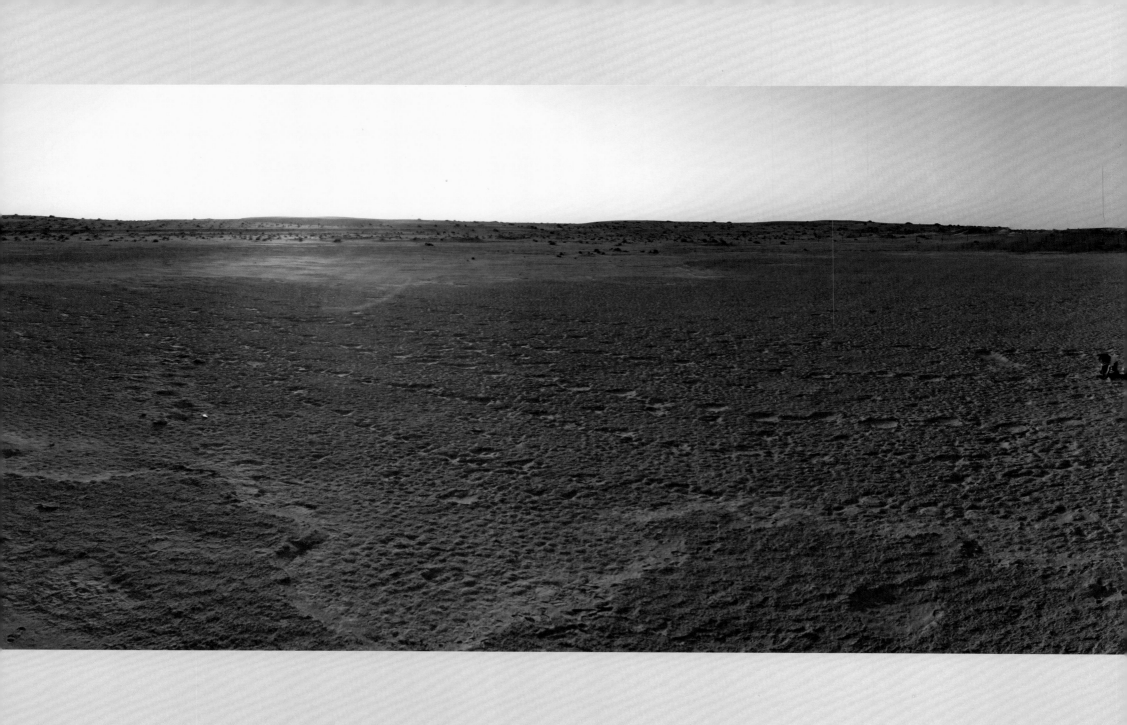

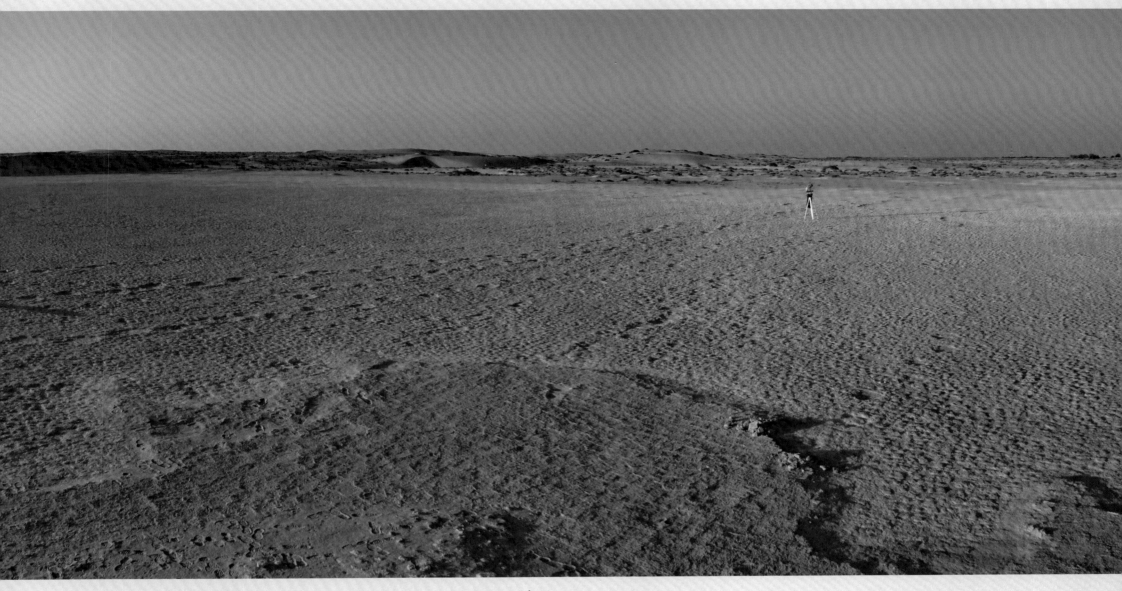

مسار آثار أقدام الفيلة في موقع مليسة ١، ١٩ ديسمبر ٢٠٠٧.

The fossil elephant trackway site of Mleisa 1, 19 December 2007.

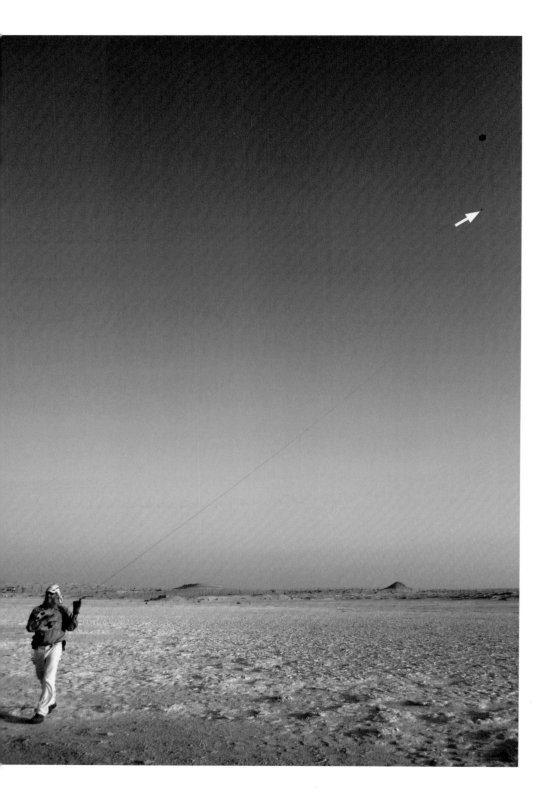

that were then stitched together by a computer into a single high-resolution photomosaic.

From this it was possible at last to understand the number, the course, and relationships of the tracks. There was one group of parallel trackways, belonging to about thirteen individuals, intersected diagonally by another single solitary one.

The stride length of elephants reflects very well their body weight, and by measuring individual tracks it was possible to work out the weights of the animals that made them. It became clear that the solitary track was produced by a very large animal, almost certainly a mature male, whereas the others were compatible with a herd of females and offspring. Consequently we can hypothesise that the social structure of these very early elephants, seven million years ago, resembled that of modern species even then.

إلى اليسار: عضو في الفريق يصوّر موقع مليسة 1 من الجو بكاميرا (السهم) تتدلى من طائرة ورقية. 2 يناير 2011.

Left: A member of the team images the Mleisa 1 site from the air with a camera (arrow) suspended from a kite, January 2, 2011.

قياس مسار الآثار في مليسة 1. 10 يناير 2011.

Measuring the Mleisa 1 trackways, 10 January 2011.

إن معرفة البنية الاجتماعية عند حيوانات منقرضة أمر صعب للغاية بطبيعة الحال، إذ لا نعود قادرين على مراقبتها مباشرة. ولكن أحياناً ما تتاح فرصة تجعل ذلك في المتناول. وهذا ما حصل عندما وُجدت مجموعة مدهشة من المتحجرات في أبوظبي.

تتكون هذه الآثار المتحجرة من مسارات منتشرة من آثار الأقدام في الداخل، أي في الصحراء قرب مليسة وعدد من المواقع الأخرى. وقد أرشدنا إليها مواطن إماراتي هو مبارك المنصوري الذي يعرف تلك المنطقة معرفة جيدة. ومن الجلي أن تلك الآثار الهائلة خلّفتها فيلة، وأن بعضها يمتد إلى 270 متراً تقريباً. وكانت واسعة ومنتشرة إلى حدٍ جعل من الصعب في البدء تقدير قيمتها. لكننا التقينا لاحقاً عالِم الآثار ناثان كريغ الذي يلتقط صوراً جوية باستعمال طائرة ورقية. أرسل كريغ طائرته فوق الآثار والتقط مئات الصور التي جرى لاحقاً تجميعها في حاسوب وتحويلها إلى صورة فسيفسائية واحدة عالية الدقة.

ساعدنا ذلك على أن نفهم أخيراً عدد آثار الأقدام ومساراتها والعلاقات ما بين الآثار. لقد كانت هناك مجموعة واحدة من المسارات المتوازية تعود إلى 13 فرداً وتتقاطع أفقياً بأثر منفرد.

اتساع خطوات الفيلة يعكس أوزان أجسامها جيداً، وهكذا أمكن احتساب أوزان تلك الحيوانات من خلال قياس كل أثر من الآثار. وبدا واضحاً أن المسار المنفرد يعود إلى حيوان ضخم يمكن الجزم بأنه ذكر بالغ، في حين تتطابق الأخرى وآثار قطيع من الإناث وصغارها. بناءً على ذلك، يمكننا أن نفترض أن البنية الاجتماعية لهذه الفيلة، التي تعود في قِدمها إلى 7 ملايين سنة خلت، كانت حتى في حينه تشبه البنية الاجتماعية عند الأنواع المعاصرة.

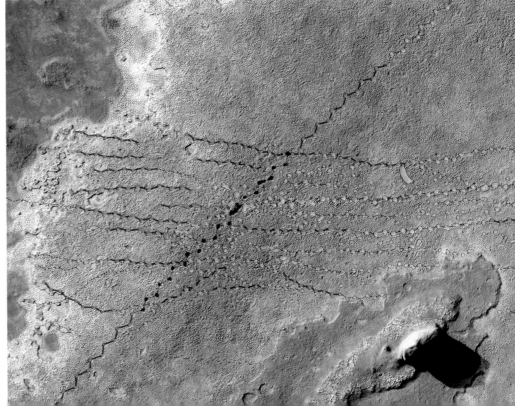

تصوير وقياس مسارات آثار الأقدام سمح لنا بأن نصنع خريطة للموقع عالية الدقة، وأن نرقّم كل مسار ونتبعه.

Imaging and measuring the tracks allowed us to produce a highly accurate map of the site, numbering and following each trackway.

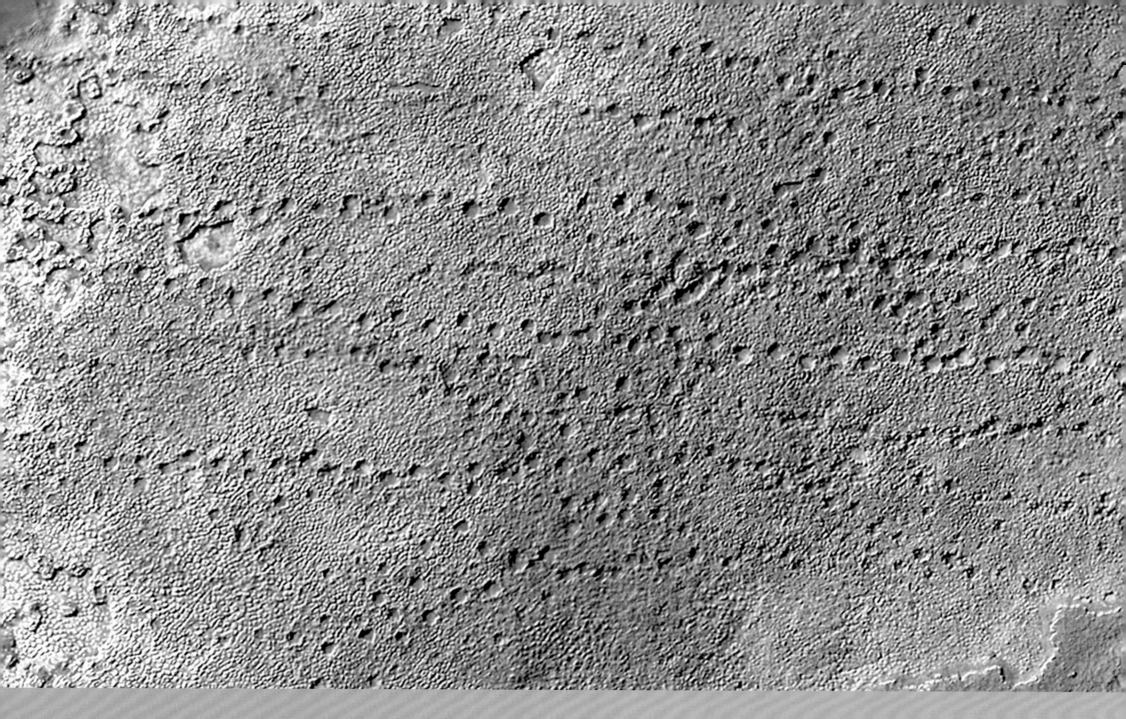

مسارات آثار الأقدام المتحجرة في موقع مليسة 1 كما صُورت من الطائرة الورقية.

The fossil trackways of Mleisa 1 as photographed from the kite.

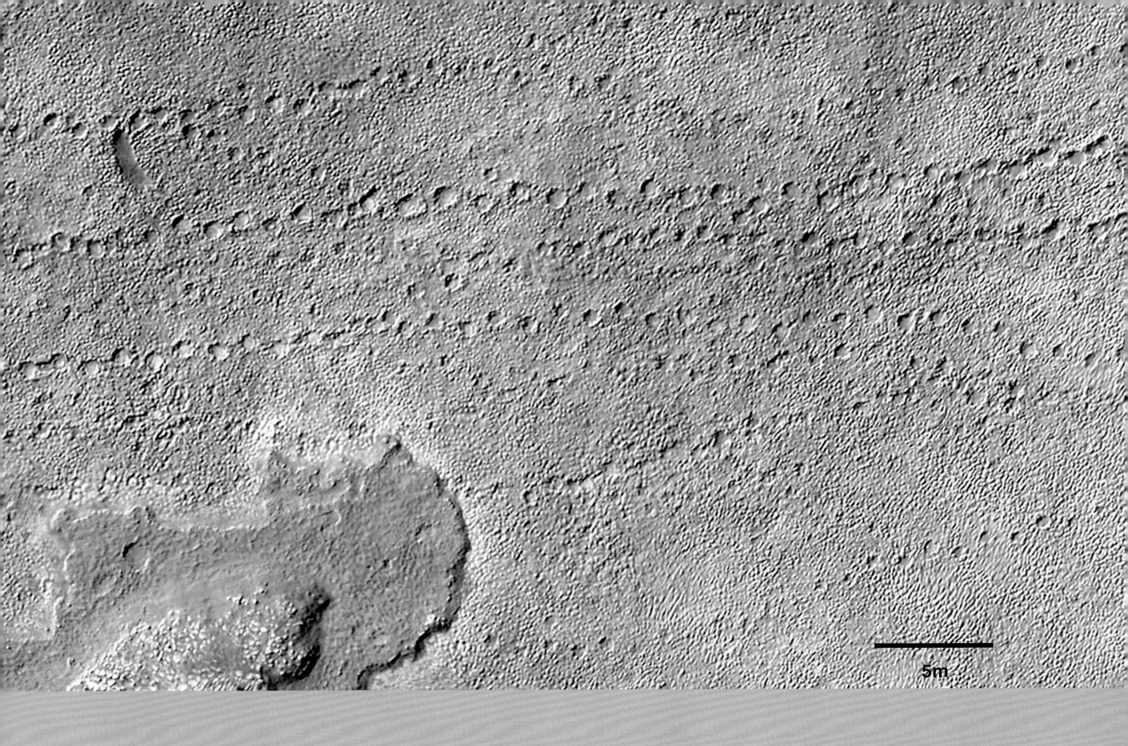

39

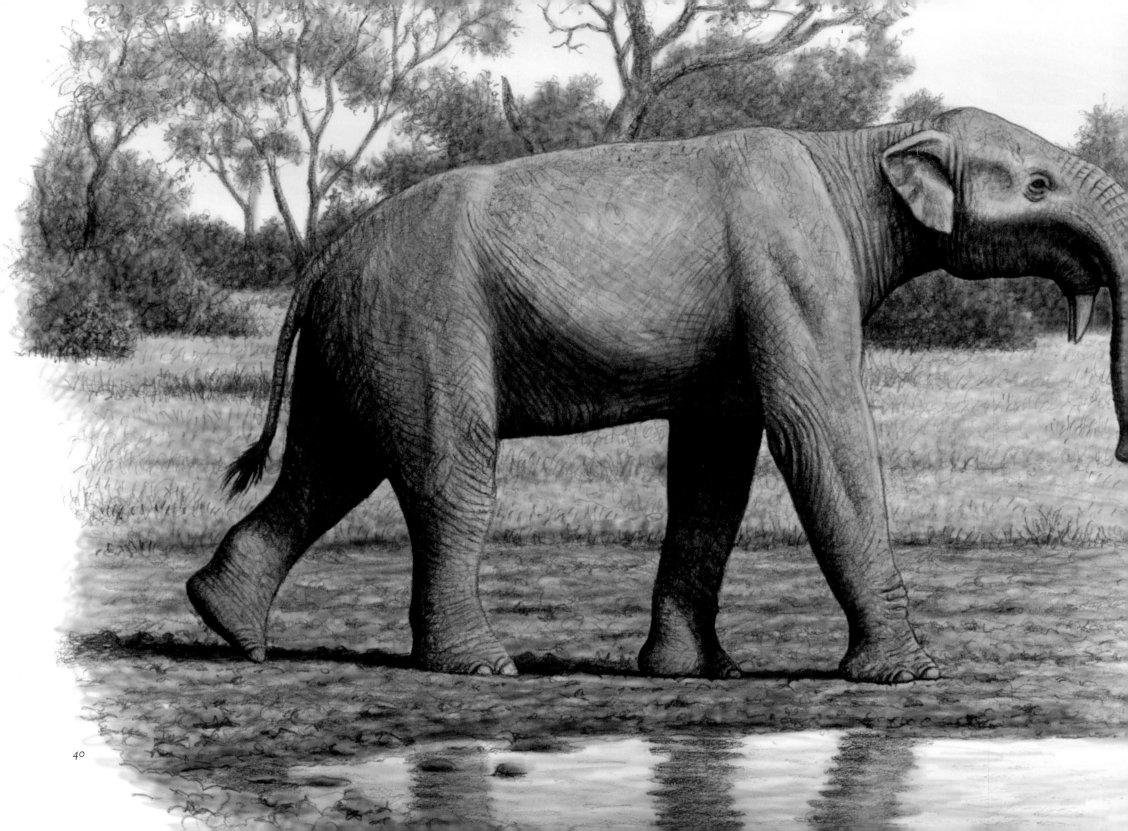

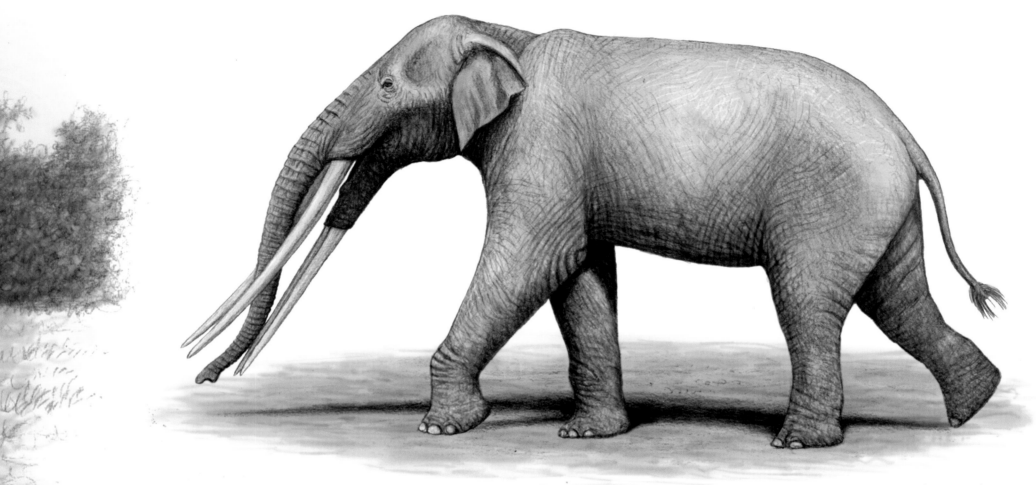

من المحتمل أن تعود آثار أقدام الفيلة في موقع مليسة 1 إلى الحيوان "سُتيجوتيتْرَابيلُودون سيرْتيكوس" ، وهو فيل منتشر نسبياً في البينونة ومعروف من الحقبة الميوسينية في ليبيا في حين وجدت أصناف أخرى منه في مواقع الأحفوريات في شرق أفريقيا. وتعتبر العينات من أبوظبي من بين الأفضل في العالم، وبوجه خاص الهيكل العظمي الكامل إلى حدٍ بعيد والذي استخرج من جزيرة الشويهات. وتوفر العينات معلومات مفيدة للغاية عن هذه الأصناف.

الصورة المقابلة: تميّز فيل "الدايْنوتيريوم" بأنياب معقوفة في الحنك السفلي. وهي معروفة من البينونة أيضاً ومن مواقع الأحفوريات ذات العمر المماثل في شرق أفريقيا.

Opposite page: Deinotherium *had distinctive downward-curving tusks in its lower jaw. It is known from the Baynunah as well as from fossil sites of similar age in East Africa.*

Stegotetrabelodon syrticus, *a relatively common elephant in the Baynunah, might have been the maker of the Mleisa tracks.* Stegotetrabelodon *is also known from the Miocene of Libya, whereas other* Stegotetrabelodon *species are known from fossil sites in East Africa. The specimens from Abu Dhabi, particularly a very complete skeleton excavated on the Island of Shuwaihat, are among the best in the world, and give much useful information about this species.*

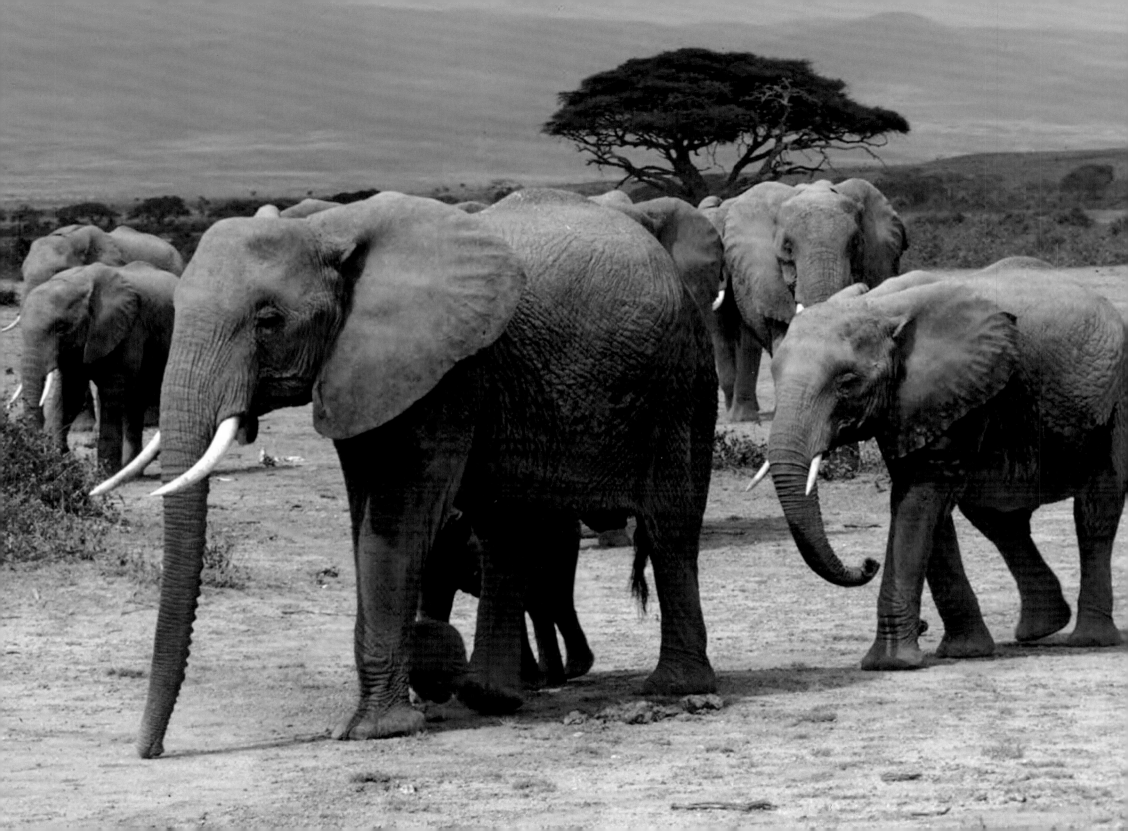

الفيلة

يعود بعض أهم وأكبر المتحجرات من أبوظبي إلى الفيلة. وفيما يعتبر الفيل الأفريقي (لوكُسودونْتا أفريكانا) أكبر الحيوانات البرية الحية، فإن حيوانات مماثلة وُجدت في الماضي ولأزمان طويلة. إلا أن نوعاً متحجراً وُجد في تشكيل البينونة (ستيجوتيتْرابيلودون سيرتيكوس) يعود إلى نوع معاصر من الفيلة ينتمي إلى العائلة الحيوانية «إليفانْتيداي». لهذا الفيل نابان ليس في الفك العلوي فحسب، كما عند الفيلة المعاصرة، بل هناك اثنان في الفك السفلي أيضاً. وهناك نوع متحجر آخر في البينونة من شكلٍ أكثر بدائية ربما انتمى إلى نوع «الأمْبيليدون». ومن الممكن أن يوجد نوع آخر معروف بفضل كسرة سن، لا غير، ينتمي إلى مجموعة غريبة وواسعة الانتشار من الحيوانات، أي «الدينوثير»، التي تتَّسم بأنياب مميزة منحنية نحو الأسفل في الفك التحتي. المتحجرات غير المألوفة المرتبطة بنوع «ستيجوتيتْرابيليدون»، وهي الأكثر انتشاراً بكثير في أبوظبي، تُمكّننا من أن نعرف عنها أكثر بكثير مما نعرف عن الأنواع الأخرى، بما في ذلك معرفة تفاصيل عن بنيتها الاجتماعية.

كلا النوعين من الفيل المعاصر، الفيل الأفريقي والفيل الهندي (إيليفاس ماكْسيموس)، يعيشان في مجموعات اجتماعية تقود القطيع فيها أم رئيسة. وكثيراً ما يتشكل القطيع من 10 إلى 20 من الإناث البالغة من الأقارب، وصغارها. أما الفيلة الفتية من الذكور فهي تغادر القطيع عند البلوغ وتعيش حياة شبه منفردة ولا تعود إلى القطيع إلا بين الحين والآخر لغرض التفاعل الاجتماعي والتزاوج.

الصورة المقابلة: عائلة من الفيلة تمر في منطقة «أمبوسيلي»، كينيا 1992.

Opposite page: An elephant family crosses through Amboseli, Kenya, 1992.

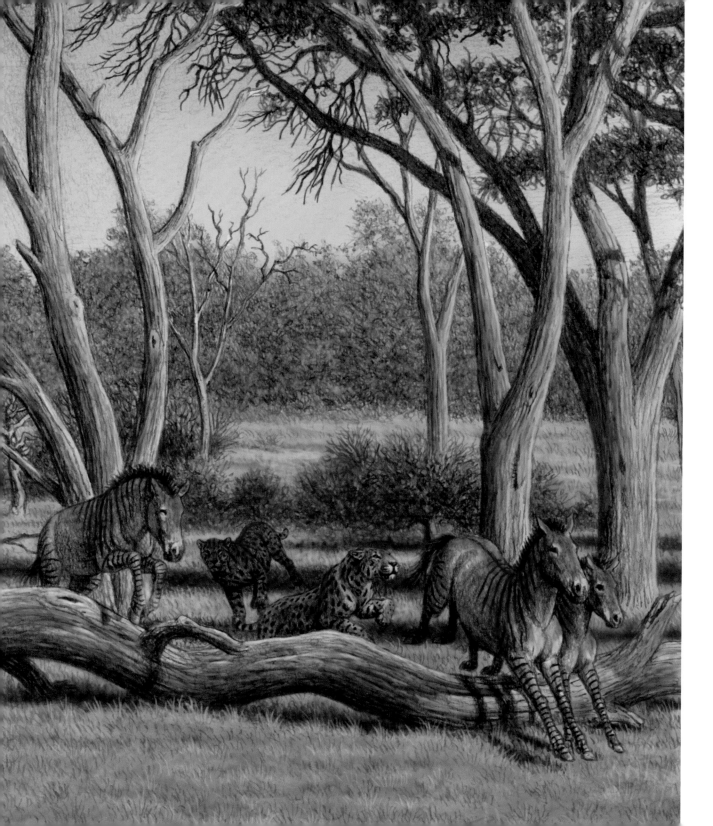

Carnivores

Carnivores are rare in any living community of animals and consequently rare as fossils, but a number are known from the Baynunah Formation. Although few in number as fossils, in life some of these beasts must have been spectacular. The largest carnivore was an impressive sabre-toothed cat, a machairodont. It was similar to a lion but had enormous stabbing canine teeth, and may have included small elephants in its diet.

إلى اليسار: أسد ضخم ذو أنياب معقوفة يطارد حصاناً ثلاثي الحوافر.

Left: A large sabre-toothed lion chases down a three-toed horse.

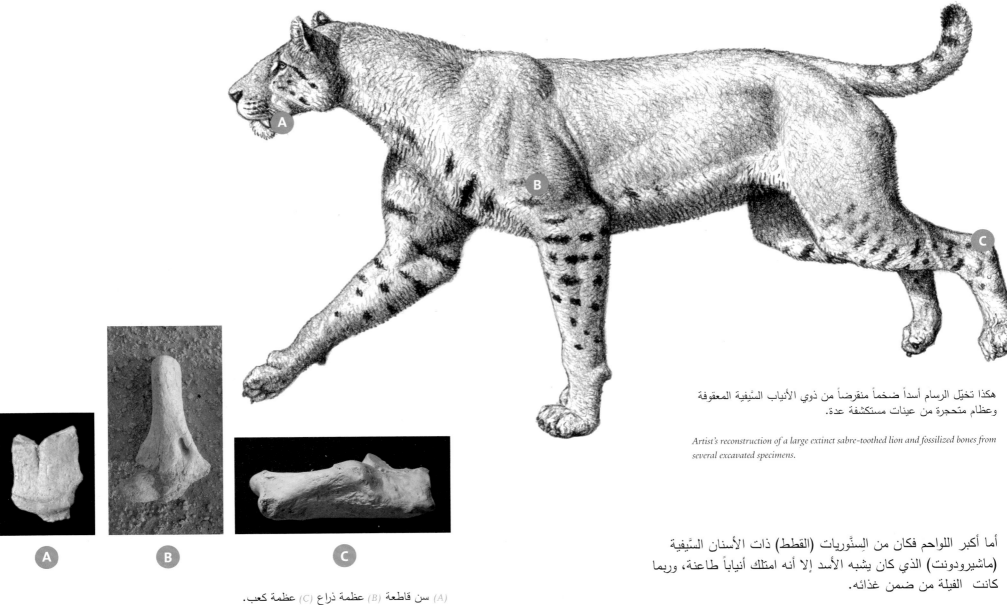

هكذا تخيّل الرسام أسداً ضخماً منقرضاً من ذوي الأنياب السَّيفية المعقوفة وعظام متحجرة من عينات مستكشفة عدة.

Artist's reconstruction of a large extinct sabre-toothed lion and fossilized bones from several excavated specimens.

أما أكبر اللواحم فكان من السِنَّوريات (القطط) ذات الأسنان السَّيفية (ماشيرودونت) الذي كان يشبه الأسد إلا أنه امتلك أنياباً طاعنة، وربما كانت الفيلة من ضمن غذائه.

(A) سن قاطعة (B) عظمة ذراع (C) عظمة كعب.

(A) A slicing tooth (carnassial) (AUH 858)
(B) A slicing tooth (carnassial) (AUH 858)
(C) Heel bone (calcaneum) (AUH 241).

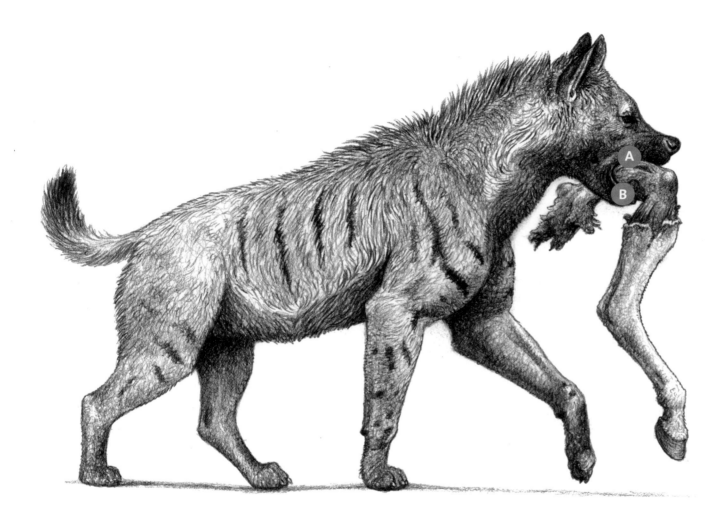
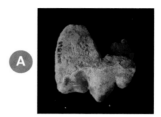
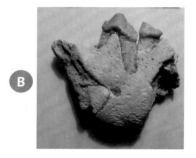

(A) سن قاطعة
(B) جزء من حنك سفلي متحجر

(A) Slicing tooth (carnassial) (AUH 1548)
(B) Part of a fossilized lower jaw (AUH 294)

رسم ضبع منقرض وعظمة متحجرة من عينات أحفورية عدة.

Artist's reconstruction of an extinct hyena and fossilized bone from several excavated specimens.

There are also two species of hyaenas, one very large and another of medium size.

وهناك أيضاً نوعان من الضِّباع، أحدهما كبير الحجم والآخر متوسطه.

عظمة زند متحجرة لحيوان صغير من أكلة اللحوم، الحمراء، 6 ديسمبر 2006.

The fossilized forearm bone (ulna) of a small carnivore (AUH 1055). Hamra, 6 December 2006.

اللواحم

اللواحم (آكلات اللحم) نادرة في أي مجموعة كان من الحيوانات، ونادرة بالتالي كمتحجرات.

ولكن يوجد عدد معروف منها في تشكيل البينونة. ورغم قلة عددها كمتحجرات فلا بد أن بعض هذه الوحوش كان مذهلاً. وشملت اللواحم الأصغر الأخرى حيواناً من فصيلة العَرْسِيّات (الموسْتيليدي) (بْليسْيوغولو بْريكوسيدينْس)، ومنها "ابن عرس" و"ابن مقرض". هذه المتحجرة تشبه حيوان "الشَّرِه" المعاصر الذي لا يتواجد إلا في المناطق الشمالية من الكرة الأرضية.

Other, smaller, carnivores include a mustelid (*Plesiogulo praecocidens*)—belonging to the group that includes weasels and ferrets. This fossil was similar to the modern wolverine, now confined to northern latitudes.

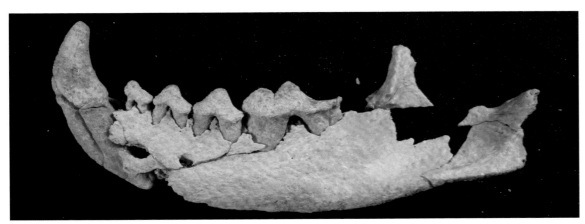

فك سفلي لحيوان صغير من آكلات اللحوم.

The fossilized lower jaw of the wolverine-like extinct mustelid Plesiogulo *(AUH 45).*

Giraffes

There are two or three species of giraffes. This is a partial skeleton of something like the extinct genus *Palaeotragus*, a relatively long-legged, long-necked form.

Another resembles *Bramatherium*, a large, short-limbed giraffe, fossils of which are also known from the contemporary Siwalik sediments in Pakistan and India, indicating another connection with Asia.

الزرافة المنقرضة "بالييوتراجوس" كما تخيلها الرسام.

Artist's reconstruction of the extinct giraffid Palaeotragus.

الزرافات

هناك نوعان أو ثلاثة من الزرافات. هذا هيكل عظمي جزئي يعود إلى ما يشبه الجنس المنقرض "بالييوتراجوس"، وهو نوع طويل السيقان والرقبة نسبياً. النوع الآخر يشبه زرافة "بْراماثِيريوم" وهي زرافة ضخمة قصيرة الأطراف، وقد وجدت متحجرات منها في حوض سيواليك في الباكستان والهند، ما يشير إلى صلةٍ أخرى بآسيا.

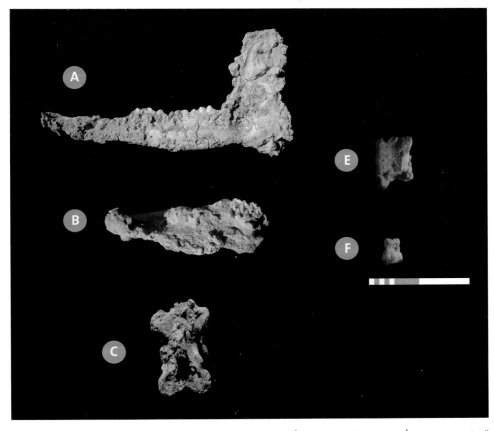
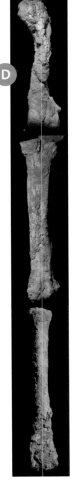

"عظام متحجرة من أحفور الزرافة المنقرضة "بالبَيوتراجوس"

Fossilized bones from an excavated specimen (AUH 837) of the extinct giraffid Palaeotragus.

(A) فك سفلي
(B) فك علوي
(C) فقرة رقبة
(D) عظام ذراع طويلة
(E, F) عظام كاحل وأصابع قدم

(A) Lower jaw (B) Upper jaw (C) Neck vertebra
(D) Long bones of the arm (E) Ankle bone (F) Toe bone

Antelopes

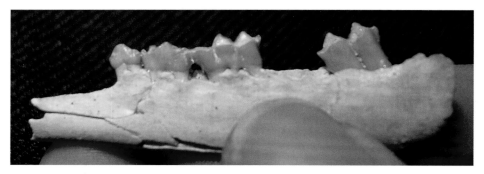

الحنك السفلي لظبي صغير منقرض، وقد أعيد تركيبه من أكثر من دزينة من قطعة.

The lower jaw of a tiny extinct antelope, reconstructed from more than a dozen pieces (AUH 1030).

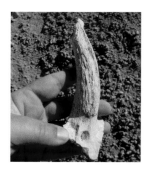

جزء من قرن متحجر يعود إلى ظبي منقرض، قرين العيش، 6 يناير 2010.

Part of a fossilized horn of an extinct antelope. Gerain al Aysh, 6 January 2010.

A diverse range of bovids or antelopes has been recognized from the fossils, some resembling Asian kinds. There are at least six species, most belonging to now-extinct genera.

Appropriately, there are ancient relatives of the gazelles that still roam Al Gharbia today. Many are represented by their distinctive ankle bones, but horn cores and jaws have been found, and even partial skulls.

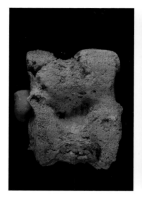 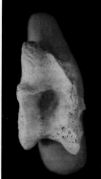 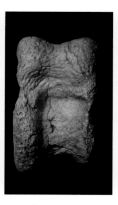

عظام كاحل متحجرة (أسْتراجالوس) تعود إلى أصناف عدة من الظباء.

Fossilized ankle bones (astragalus) of several different species of antelopes (left to right: AUH 1569, AUH 1472, AUH 1188, AUH 1225).

الظِّباء

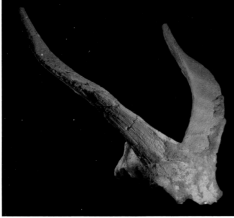

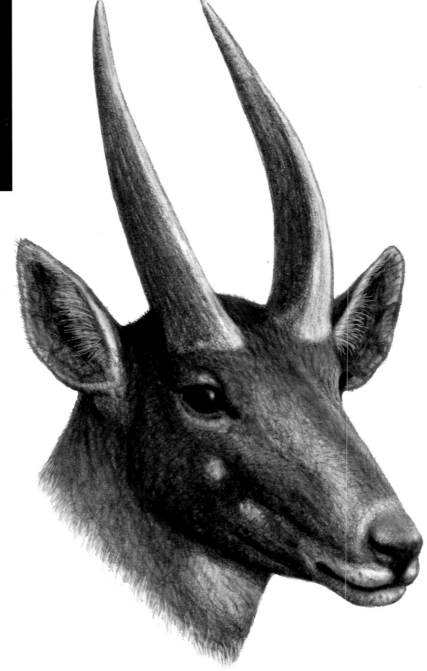

One of the best specimens is part of the skull of a large animal called *Tragoportax*, related to the Nilgai of India. This artist's reconstruction shows a closely related *Tragoportax* antelope from a site of similar age in Kenya.

في الأعلى: جزء من جمجمة بقرنيها تعود إلى الظبي المنقرض "تْراغوبورْتاكْس سايرينيكوس".

Top: Partial skull with horns of the extinct antelope *Tragoportax cyrenaicus* (AUH 442).

إلى اليمين: الظبي المنقرض كما تخيله الرسام.

Right: Artist's reconstruction of *Tragoportax*.

جرى التعرف إلى تنوّع من البقريات في الأحافير المكتشفة، بعضها يشبه الأنواع الآسيوية. وهناك ما لا يقل عن ستة أنواع منها ينتمي معظمها إلى أجناس منقرضة. وهناك حيوانات من أقارب الغزلان من الزمن الغابر لا تزال تجول اليوم في "الغربية". ويتمثّل كثير منها بعظام كواحلها المميزة، وقد وُجدت متحجرات من قلوب قرونها وأحناكها بل وُجدت حتى أجزاء من جماجمها. هذه واحدة من أفضل العيّنات: جزء من جمجمة حيوان كبير يسمى "تْراغوبورْتاكْس" وهو من أقرباء "النِّلجاي" الهندي. ويظهر الرسم، كما أعاد الفنان تركيبه، ظبياً قريبا للغاية من ال"تْراغوبورْتاكْس" وُجد في موقع أحفوري موازٍ في القدم في كينيا.

Horses

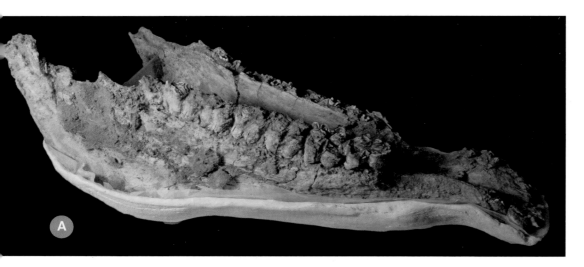

الحنك السفلي في أثناء تنظيفه وحفظه. أبو ظبي، 25 ديسمبر 2011.

The lower jaws (AUH 1284) during cleaning and conservation of the fossil. Abu Dhabi, 25 January 2011.

Horses inhabited the plains by the river system and probably browsed bushy leaves rather than the grass favoured by their modern counterparts. Two kinds have been found; both were relatively small and, unlike the modern horse with just one toe on each foot, these had three. Both belonged to the extinct genus *Hipparion*. One is so far unnamed, but the other is a new species and has been called *Hipparion abudhabiense* in honour of the Emirate.

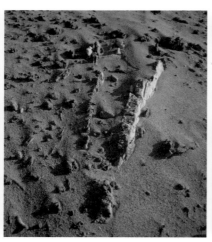
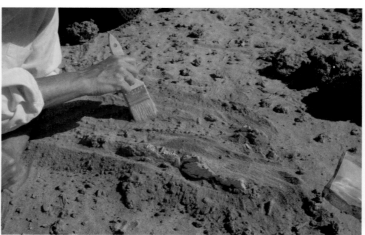
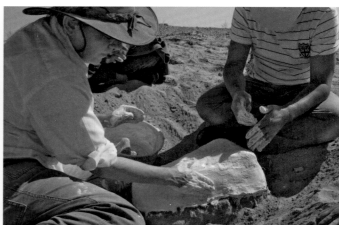

الحنك السفلي المتحجر وشبه المكتمل الذي يعود إلى حصان منقرض كما اكتشف وجرى استخراجه في الحمرا. 17-24 2008.

The almost complete fossilized lower jaws of an extinct horse, as discovered and being excavated at Hamra, 17–24 December 2008.

الخيول

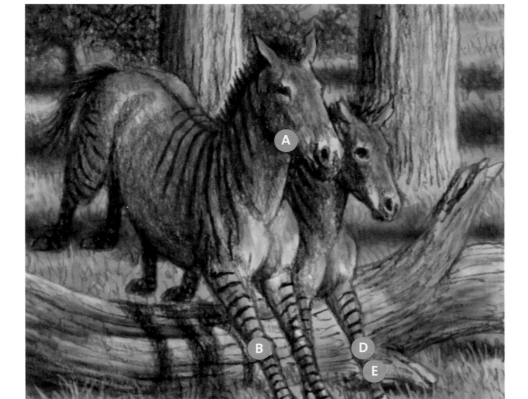

كانت الخيول تعيش في السهول المحاذية لنظام النهر، ويرجح أنها كانت تأكل أوراق الشجيرات أكثر مما كانت ترعى الحشائش - كما تفعل الخيول المعاصرة. وقد اكتُشف منها صنفان، كلاهما صغير الحجم نسبياً ويمتلك 3 حوافر في كل قدم مقابل حافر واحد عند الخيول المعاصرة. وكلا الصنفين ينتميان إلى جنس "الهيباريون" المنقرض. وفيما لم يجر تسمية الأول فقد أطلق على الثاني، وهو من نوع جديد، إسم "هيبّاريون ابوظبيانس" تكريماً للامارة.

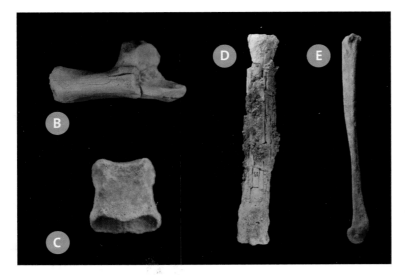

(A) الحنك السفلي
(B) عظمة كعب (كالْكانيوم)
(C) عظمة إصبع قدم (فالانكْس)
(D) عظمة قدم متوسطة
(E) عظمة قدم جانبية

(A) The lower jaws (AUH 1284)
(B) Heel bone (calcaneum) (AUH 1609)
(C) Toe bone (phalanx) (AUH 1581)
(D) Central foot bone (central metapodial) (AUH 1499)
(E) Side foot bone (lateral metapodial) (AUH 1584)

رسم لحصان منقرض وعظام متحجرة من عينات عدة.

Top left: Artist's reconstruction of an extinct horse and fossilized bones from several specimens.

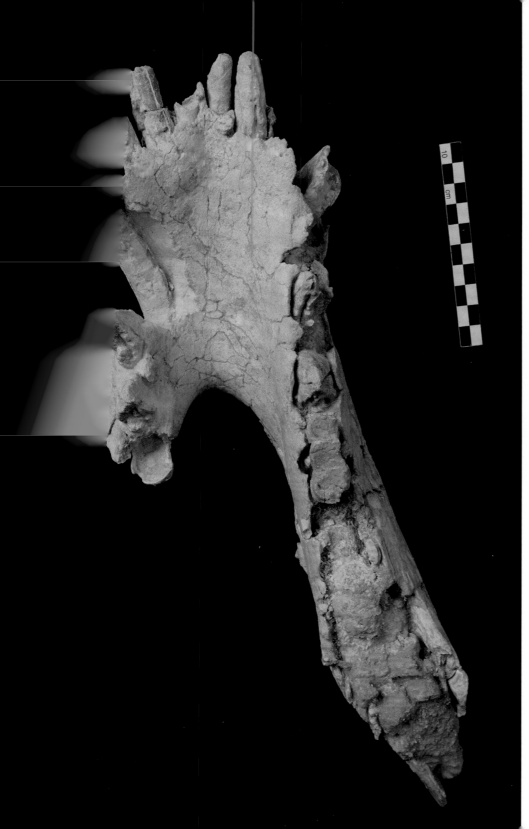

Hippopotamuses

Hippos are quite abundant in the Baynunah fossil record and were more closely related to the living West African hippopotamus, *Choeropsis,* than to the eastern African one, *Hippopotamus.* But they are sufficiently different from both to have their own generic name—*Archaeopotamus.* They are similar to fossils from the Kenyan fossil site of Lothagam of about the same period. Hippos spend a lot of time in the water but at night emerge onto land to feed on grass and other vegetation.

إلى اليسار: الحنكان المتحجران لفرس نيل صغير وجد في الشويهات، 1992.

Left: The fossilized lower jaws of a young hippopotamus (AUH 481) found on Shuwaihat in 1992.

الصورة المقابلة: مجموعة أخرى من أحناك فرس النهر في أثناء استخراجها. المطلعيات، 11 يناير 2011.

Opposite page: A set of hippopotamus jaws during excavation (AUH 1701). Matlaiyyat, 11 January 2011.

البِرنيق - أو فرس النهر

يوجد البرنيق بوفرة في سجل أحافير البينونة. وكان أقرب إلى فرس النهر المعاصر في غرب أفريقيا، والمسمى "خيوروبْسيس" أكثر من قربه إلى فرس النهر المعاصر في شرق أفريقيا، أو "هيبوبتاموس". لكن برنيق البينونة يختلف بما يكفي عن كليهما بحيث يستحق اسمه الخاص: "آركيوبوتاموس". والاحافير تشبه تلك المتحجرات المكتشفة في موقع "لوتاغام" في كينيا وتعود إلى العصر نفسه تقريباً. يقضي فرس النهر الكثير من الوقت في الماء إلا أنه يخرج من الماء إلى البرّ ليلاً ليقتات على الحشيش والأعشاب الأخرى.

Pigs

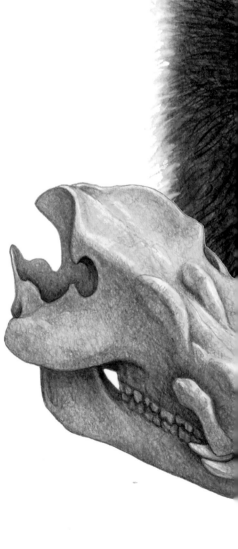

Pigs are known from two species. One is called *Nyanzachoerus syrticus*, a genus also found in eastern Africa; the same species is found as a fossil in Libya. The other is *Propotamochoerus hysudricus*, which shows a connection with Asia, being also known from northern Indian and Pakistani Siwalik sediments dated between about 10 and 7 million years ago.

الخنازير

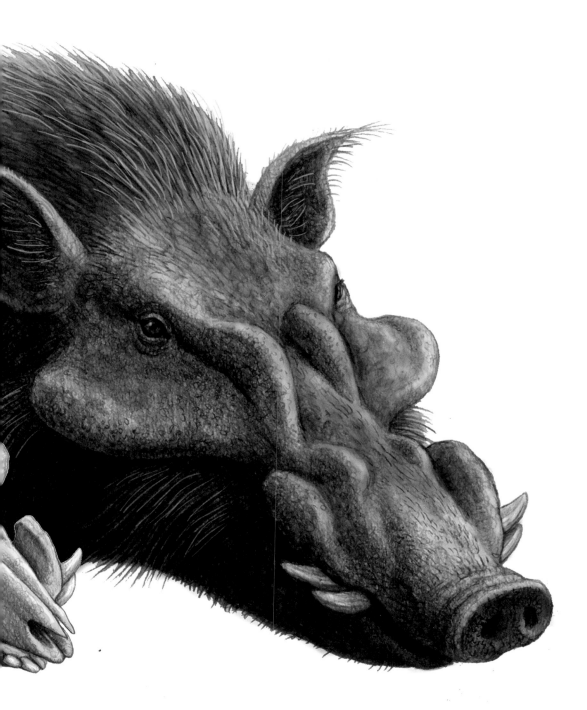

عُرف من الخنازير نوعان. الأول يدعى "نيانزا خيوروس سايرتيكوس"، الموجود أيضاً في شرق أفريقيا. كما وُجد النوع نفسه في ليبيا. أما النوع الثاني فهو "بروبوتا موخيوروس هايسدريكوس" الذي يُظهر صلةً بآسيا حيث عُرف أيضاً في ترسّبات سيواليك في شمال الهند وباكستان في المرحلة التي تعود إلى نحو 10 إلى 7 ملايين سنة خلت.

الصورة المقابلة: ضرس خنزير منذ ما قبل التاريخ وجد في الحضوانية، 11 يناير 2010.

Opposite page: A fossilized tooth of a prehistoric pig as found in the field (AUH 1578). Hadwaniya, 11 January 2010.

إلى اليسار: رسم خنزير "نيانزاخويروس" المنقرض وجمجته كما تخيلهما الرسام.

Left: Artist's reconstruction of the extinct pig Nyanzachoerus and its skull.

Monkeys

Fossil monkeys are exceedingly rare in the Baynunah sediments, and indeed in most places. This single canine tooth of a monkey was found in 1989, and then an isolated cheek tooth was discovered 20 years later. These two fragments are the only fossil monkeys from the whole of Arabia.

From the first tooth it was hard to know much about the monkey it came from, but the second provided much more information. It appears to belong to an animal related to the modern vervet monkey, a group known as guenons. This is very surprising, and for at least two reasons. The first is that guenons have not been known before in the fossil record earlier than three million years ago. So this find roughly doubles their known age of origin. The second surprising fact is that guenons have not been found at all outside continental Africa, either as fossils or among monkeys alive today.

سن منفردة تعود إلى قرد صغير لحظة اكتشافها.
الشويهات، 3 يناير 2009.

Left: A single tooth of a small monkey, at the moment of discovery (AUH 1321). Shuwaihat, 3 January 2009.

القردة

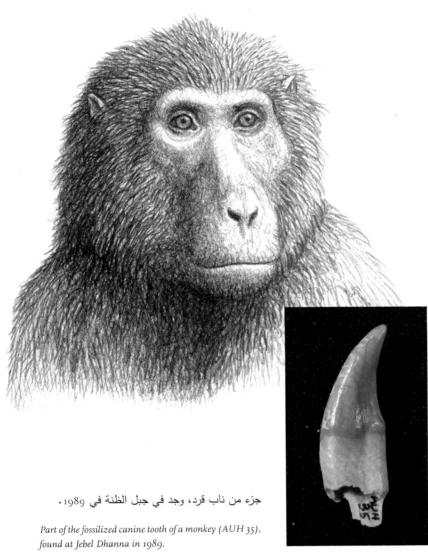

جزء من ناب قرد، وجد في جبل الظنة في 1989.

Part of the fossilized canine tooth of a monkey (AUH 35), found at Jebel Dhanna in 1989.

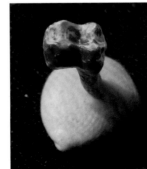

ضرس متحجر يعود إلى قرد صغير وجد في الشويهات في 2009.

The fossilized molar tooth of a small monkey (AUH 1321), found at Shuwaihat in 2009.

تزداد متحجرات القرود ندرةً في ترسبات البينونة، بل وفي معظم الأماكن في الواقع. ناب القرد المنفرد هذا وُجد في العام 1989. وبعد ذلك بعشرين عاماً جرى اكتشاف سن معزولة تعود إلى وَجَنة. وهذان الجزءان من المتحجرات يعودان إلى القردة الوحيدة المعروفة في كل الجزيرة العربية.

كان من الصعب معرفة الكثير من خلال السن الأولى عن القرد صاحبها. أما الثانية فقد وفرت لنا معلومات أكثر بكثير. ويبدو أن ذاك القرد ينتمي إلى حيوان يعود إلى نوع «الفَرفت» المعاصر، من مجموعة معروفة باسم الغَينون. وهذا مفاجئ لسببين على الأقل. الأول هو أن قرود الغينون لم تُعرف في سجلات الأحافير من قبل بما هو أقدم من 3 ملايين سنة. لذا فهذا الاكتشاف يضاعف تقريباً عمر أصل هذه القردة. السبب المفاجئ الثاني هو أن قرد الغينون لم يُكتشف على الإطلاق خارج القارة الأفريقية، لا كمتحجرات ولا بين القردة الحية اليوم.

Rodents

A number of rodents—rats, mice, squirrels—have been found at Baynunah, mainly from isolated teeth. To retrieve these very small fossils, special techniques involving sieving sand and examining the resulting sediment laboriously were used.

This work has produced examples of jerboas, or jumping mice, and a range of true mice, or murids, belonging to at least five different species. One is a previously unknown gerbil and has been named for the region, *Abudhabia baynunesis*. Since its discovery, it, or other new species of the same genus, has been found in several other parts of the Old World. Gerbils are generally regarded as being adapted to very dry environments. There are also specimens of a new genus and species attributable to the family of cane rats, which has been named *Protohummus dango*.

A squirrel and a shrew have also been discovered.

الصورة المقابلة: سن جرذ كبيرة متحجرة (ثُرايونومايْداي) على وعاء جامعها (السهم) بين حصى صغيرة وقطع من العظم المتحجر. راس القلعة، 29 ديسمبر 2008.

Opposite page: A single fossilized cane rat (Thryonomyidae) tooth sits on a collector's pan (arrow) amid pebbles and bits of fossil bone. Ras al Qal'a, 29 December 2008.

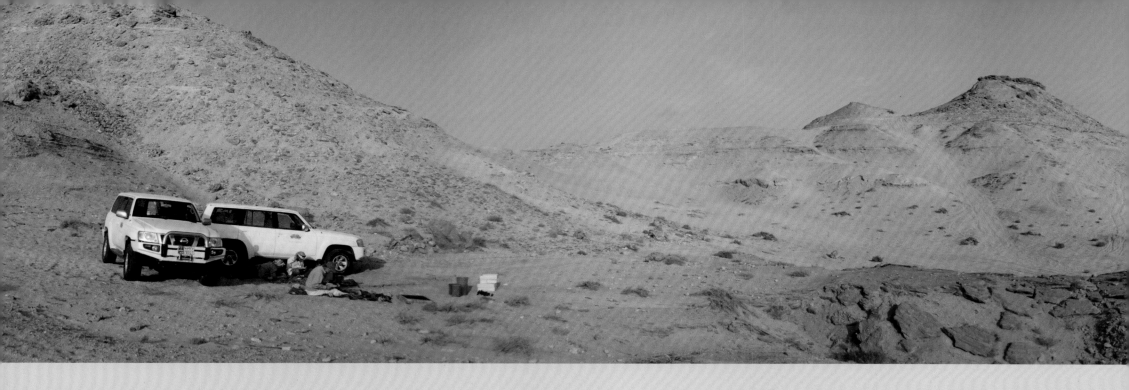
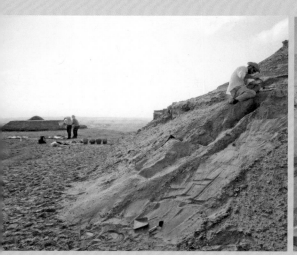
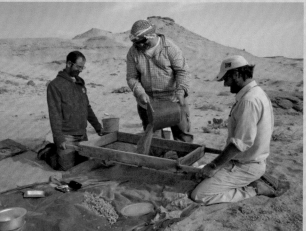
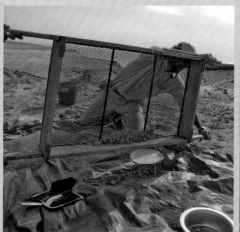

تنخيل للبحث عن أسنان ومتحجرات أخرى صغيرة. راس القلعة، الشويهات، الحارمية، 2008–2011.

Sieving for rodent teeth and other tiny fossils. Ras al-Qal'a, Shuwaihat, Harmiyya, 2008–2011.

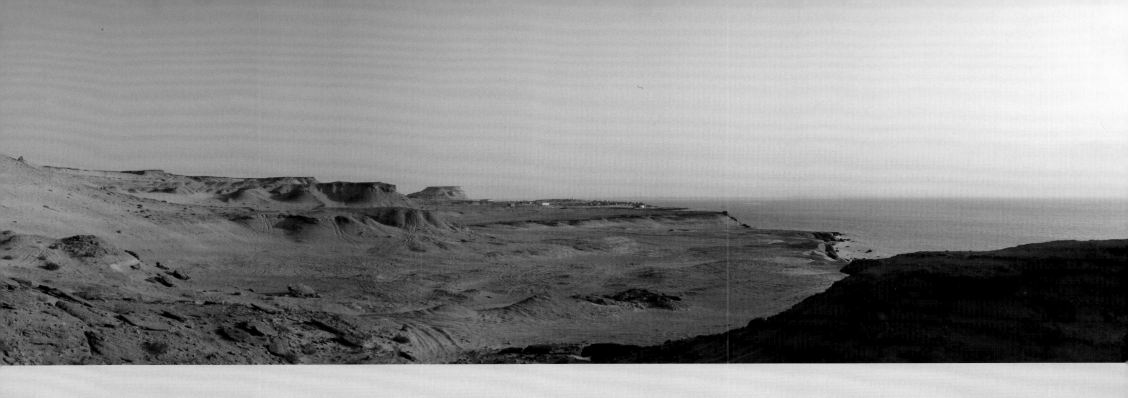

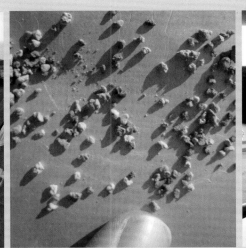
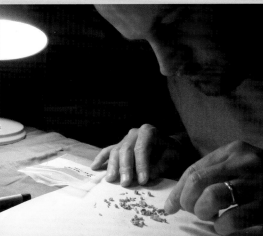

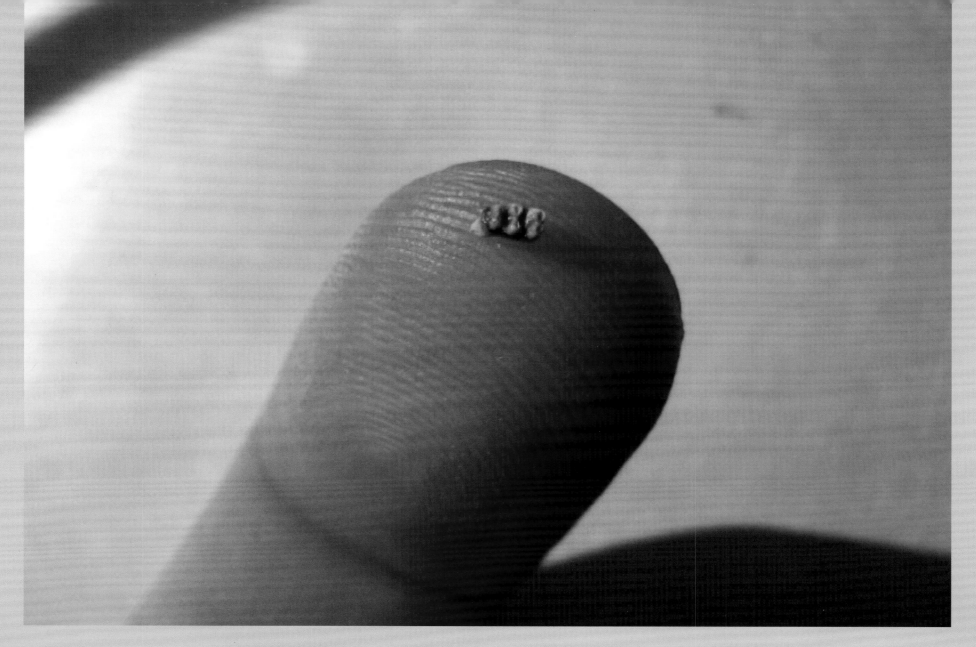

سن متحجرة مفردة تعود إلى حيوان قارض منذ ما قبل التاريخ وقت اكتشافها. الشويهات، 4 يناير 2010.

A single fossilized tooth of a prehistoric rodent as it was found. Shuwaihat, 4 January 2010.

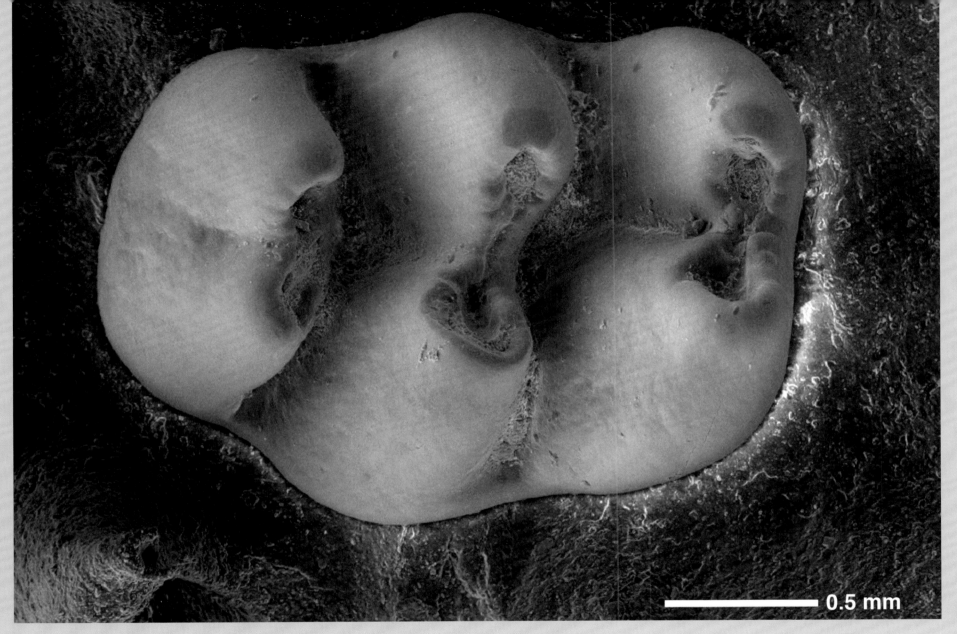

ضرس حيوان قارض كما يبدو عبر مكبر مسح إلكتروني.

A cheek tooth of a rodent as revealed through a scanning electron microscope (AUH 1432).

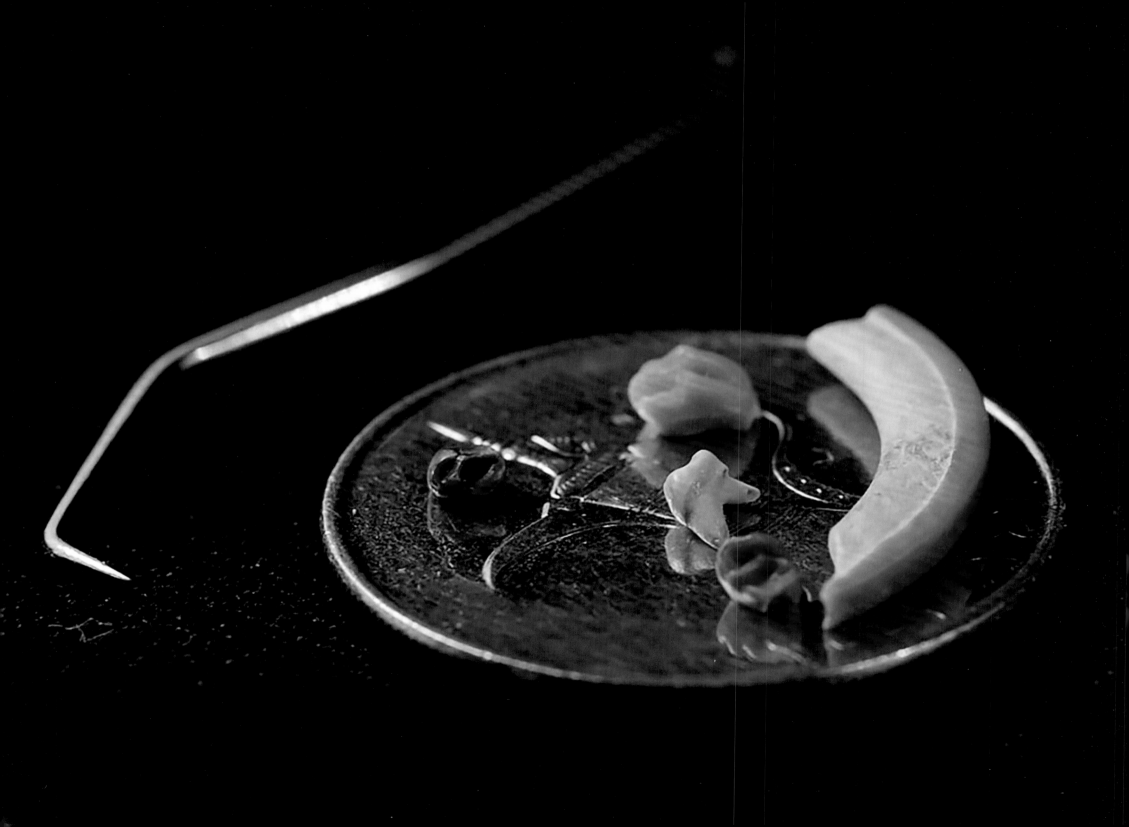

القوارض

هناك عدد من القوارض كالجرذان والفئران والسناجب التي جرى تحديدها أساساً من خلال أسنان معزولة. استخراج هذه الأحافير الدقيقة تطلّب استخدام تقنيات خاصة تشمل تنخيل الرمل وفحص الترسبات الناتجة عنه في عمل مضنٍ.

أنتج هذا العمل نماذج من اليربوع، أو الفئران القافزة، وتنويعة من الفئران الحقيقية، أو الفئران المريدة التي تنتمي إلى ما لا يقل عن خمسة أنواع. أحد هذه الأنواع هو فأر العضل (الغربيل) وهو نوع لم يكن معروفاً من قبل، لذا سمي باسم المنطقة: «أبوظبيا بينونينسيس». ومنذ اكتشافه عُثر عليه في أماكن أخرى من العالم القديم. وتعتبر فئران العضل عموماً متكيفة والبيئات شديدة الجفاف. وهناك أيضاً نماذج تُعزى إلى نوع وصنف جديدين يعودان إلى عائلة جرذان «قواطع القصب»، والتي سُميت «بروتوحمّص دانجو». وقد جرى أيضاً اكتشاف سنجاب و«زبّاب».

Birds

Birds would no doubt have been abundant and diverse around the Baynunah River system, but their bones are fragile and do not easily preserve as fossils.

Consequently the best known bird remains are pieces of fossil ostrich-like eggshell which are locally very numerous. There are two kinds. The most common one is most like the modern African ostrich, *Struthio camelus*, and is named *Diamantornis laini*, a form that is also known from rocks of similar age in Namibia and Kenya.

There are also fossils of the beast that probably laid these eggs, pieces of leg bones and a remarkable, complete pelvic girdle—perhaps 30% larger than that of the modern ostrich —which is possibly unique in the fossil record.

The other type of eggshell is more rare and is similar to that of the extinct giant elephant-bird *Aepyornis*, of Madagascar, sometimes implicated in the Arabic myth of the Roc.

Among other birds that have so far been identified are representatives of the genus *Anhinga*—the darter, and members of the family Ardeidae—herons and bitterns.

كسرة من بيضة متحجرة تعود إلى طائر مسطّح الصدر يشبه النعامة.

The fossilized eggshell fragment of Diamantornis, *an ostrich-like ratite (AUH 1605).*

قطعة من قشرة بيضة متحجرة تشبه بيضة طائر الفيل. الحضوانية، 14 يناير 2010.

Fragment of a fossilized eggshell that resembles the egg of an elephant bird (AUH 1602). Hadwaniya, 14 January 2010.

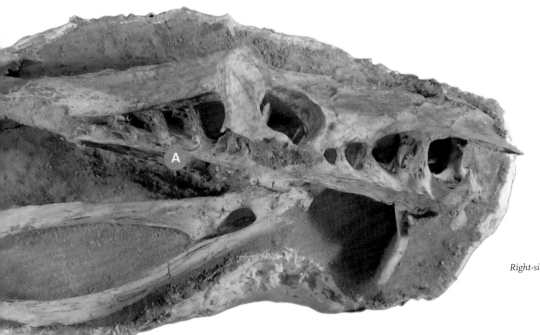

حوض نعامة كبرى متحجرة من الجانب الأيمن.

Right-side view of the pelvis of a large fossil ostrich (AUH 1134).

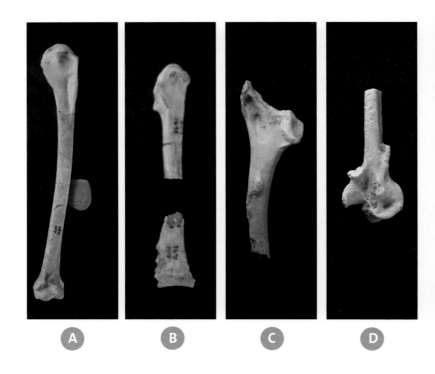
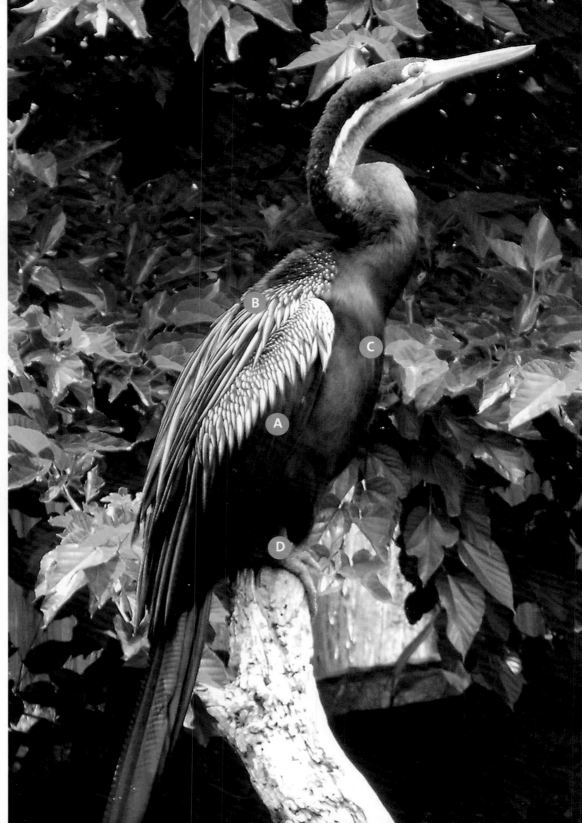

الزقة الأفريقية الحية (أنهنغا روفا) والعظام المتحجرة التي تعود إلى طيور مماثلة.

Right and above: The living African Darter (Anhinga rufa) and excavated fossilized bones of similar birds (left to right: AUH 1106, AUH 1496, AUH 1113, AUH 1489).

الطيور

لا شك في أن الطيور كانت منتشرة بكثرة وتتوّع في نظام نهر البينونة، إلا أن عظامها هشّة ما يصعّب حفظها كمستحاثات. لذلك، فإن بقايا الطيور المعروفة أكثر من غيرها هي قطع متحجرة من قشرة بيض حيوان يشبه النعامة، والتي يمكن العثور عليها بكثرة في الموقع. وهناك نوعان منها: النوع الأكثر انتشاراً هو الذي يشبه النعامة الأفريقية المعاصرة «سْتروثُيو كاميلوس»، ويسمى «دِيامِنتورنيس لايِيني» وهو معروف أيضاً في صخور من العمر نفسه في ناميبيا وكينيا. هناك أيضاً أجزاء متحجرة من حيوان ربما كان يضع بيضاً. وهي أجزاء من عظام ساقٍ وطوق حوضٍ كامل بشكل لافت. والحوض أكبر بثلاثين بالمئة من مثيله في النعامة المعاصرة، الأمر الذي يمكن أن يكون فريداً في سجلات المستحاثات.

الصنف الآخر من قشر البيض أكثر ندرةً وهو لطائر يشبه طائر الفيل العملاق المنقرض، «إيْبْيُورِنِيس»، في مدغشقر، وهو الطائر الذي يُربط أحياناً بطائر الرخ العربي الأسطوري، وهو طائر مفترس تذكره «ألف ليلة وليلة».

وتشمل الطيور التي جرى تحديدها حتى الآن طيوراً تنتمي لجنس الزُّقة –أو «الأنْهِنْجا» –وهو طائر شبيه بالغاق، وتشمل كذلك أعضاء من عائلة البَلشونيات (الأرْدايْد) مثل مالك الحزين والواق.

Reptiles

The most common fossil reptiles from the Baynunah are the fearsome aquatic kind—crocodiles. Here is the head of a large one before excavation, which is similar to the present-day African Nile Crocodile, *Crocodylus niloticus*. These crocodiles are adept at eating mammals, sometimes quite large ones, and they no doubt lurked in the shallows for animals coming to the river and neighbouring ponds to drink, as do their modern counterparts.

The most common crocodile fossils, however, are not whole heads, but teeth and the bony plates, or scutes, which grow in the skin and lead to the crocodile's characteristic bumpy appearance.

There are also specimens representing one or two species of gavial, another kind of crocodile, which have quite slender and very long jaws particularly suited to devouring fish. Although once widespread, the only living species of this group is now highly endangered and confined to northern parts of the Indian subcontinent.

Other fossil reptiles from the Baynunah Formation include tortoises and turtles, both terrestrial and aquatic. Among these are fragments of the very large, land-living *Geochelone*.

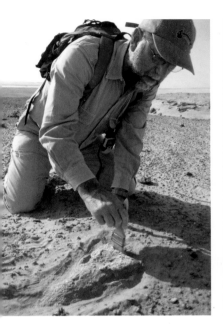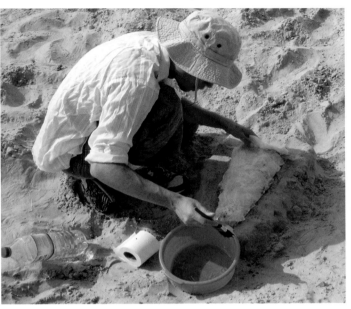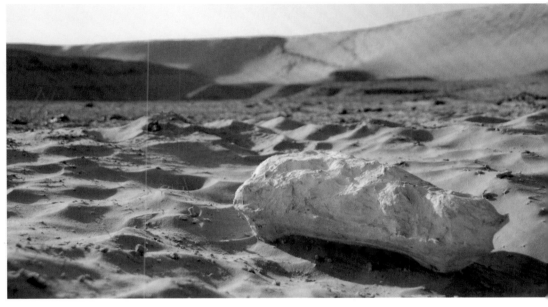

Opposite page and above: A fossilized crocodile skull being excavated and placed in a protective plaster jacket for transport (AUH 1568). Gerain al Aysh, 8 January 2010.

في الجهة المقابلة وفوق: جمجمة تمساح متحجرة في أثناء استخراجها ووضعها في غلاف واقٍ من الجبس لنقلها. قرين العيش، 8 يناير، 2010.

Similar though not necessarily closely related forms are now best known from the Galápagos and some Indian Ocean islands. Other, smaller turtles lived in the waters of the river system. There are also fossil traces of a variety of snakes, and probably at least one lizard.

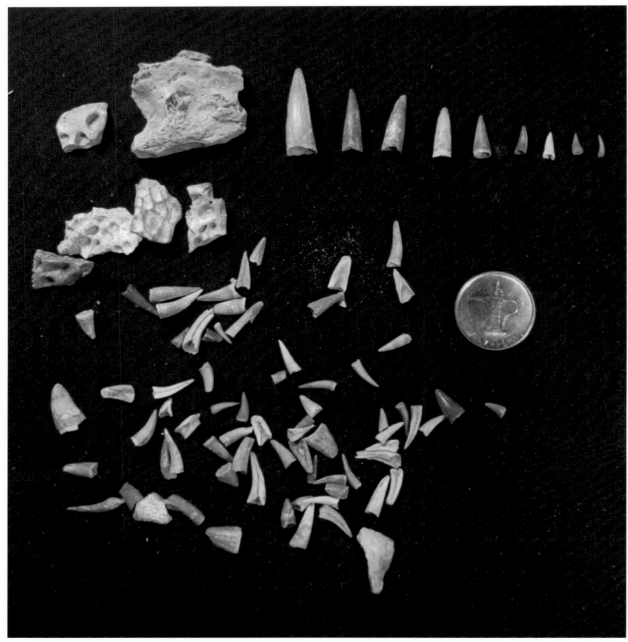

Crocodile teeth and bones from various localities in Al Gharbia.

أسنان تمساح وعظامه من مواقع متعددة في الغربية.

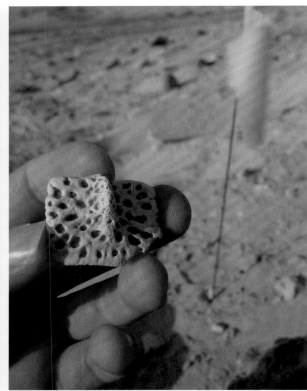

عظمة ظهر تمساح متحجرة. الشويهات، 22 ديسمبر 2007.

A fossilized crocodile scute bone (AUH 1198). Shuwaihat, 22 December 2007.

روث متحجر يعود غالباً إلى تماسيح.

Coprolites (fossil dung), most likely of crocodiles (AUH 1473).

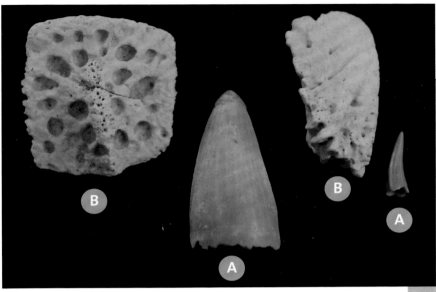

(A) أسنان و (B) عظام تماسيح متحجرة.

(A) Fossilized crocodile teeth and (B) scutes (AUH 1481)

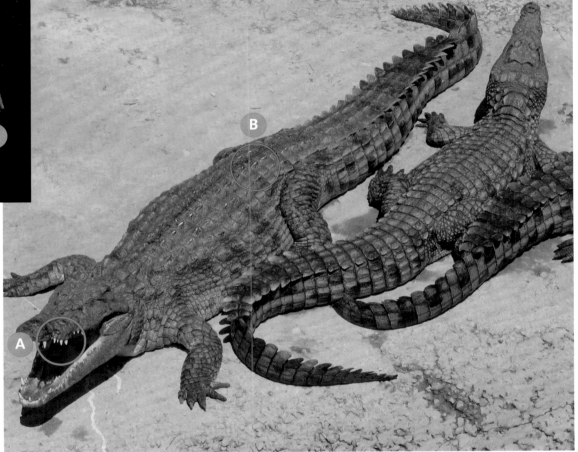

تمساح النيل (كروكودايلوس نيلوتيكوس).

The Nile Crocodile (Crocodylus niloticus).

غير أن أكثر أجزاء التماسيح الأحفورية انتشاراً ليست رؤوساً كاملة بل أسنان وصفائح عظمية، أو حراشف كبيرة تنمو في الجلد وتؤدي إلى تكوّن النتوءات البارزة التي تميز شكل التماسيح. هناك أيضاً نوع أو اثنان من الغَريال (التمساح الهندي) الذي يتمتع بفك طويل رفيع ملائم بشكل خاص لالتهام الأسماك. ورغم انتشارها الواسع في الماضي فإن الأنواع الوحيدة من هذه المجموعة التي ما زالت باقية تتعرض اليوم لخطر الانقراض ويقتصر وجودها على الأجزاء الشمالية من شبه القارة الهندية.

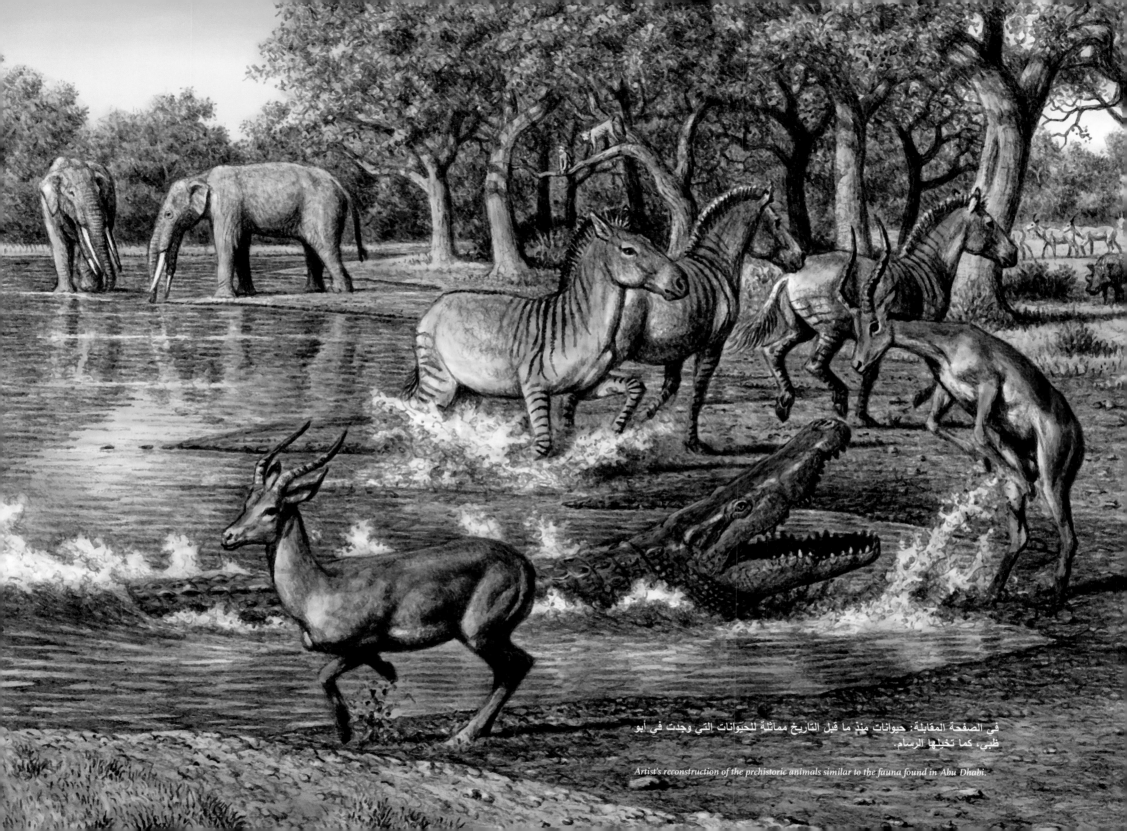

في الصفحة المقابلة: حيوانات منذ ما قبل التاريخ مماثلة للحيوانات التي وجدت في أبو ظبي، كما تخيلها الرسام.

Artist's reconstruction of the prehistoric animals similar to the fauna found in Abu Dhabi.

الزواحف

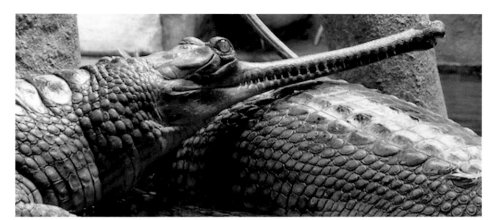

Above: The living Indian Gavial (Gavialis gangeticus). Below: A partial fossilized jaw of the extinct gavial-like Ikanogavialis (AUH 56, Shuwaihat, 1989).

الغَريال (التمساح الهندي) الحي، وجزء من حنك يعود إلى غريال منقرض (إيكانوجافياليس). الشويهات، 1989.

الزواحف الأحفورية من تشكيل البينونة تشمل سلاحف برّية ومائية، ومنها شظايا من السلاحف البريّة الضخمة من نوع "جِيوشِيلون". وهناك أشكال مشابهة منها – من دون وجود قرابة وثيقة فيما بينها بالضرورة. والأشهر هي تلك الموجودة على جزر "جالاباجوس" وبعض جزر المحيط الهندي. وتعيش سلاحف أصغر في مياه نظم الأنهر. وهناك أيضاً آثار متحجرة لتنوع من الأفاعي وربما عظاءة واحدة على الأقل.

أكثر الزواحف المتحجرة انتشاراً هي التماسيح المائية المخيفة. هنا يظهر رأس تمساح كبير قبل انتشاله، وهو يشبه تمساح النيل الأفريقي المعاصر: "كُروكودايْلُس نيْلوتيكوس". إعتادت تلك التماسيح افتراس الثدييات التي كانت تشمل أحياناً ثدييات ضخمة، ولا شك أنها كانت تكمن في المياه الضحلة في انتظار الحيوانات التي ترد النهر والبرك المجاورة لتشرب، تماماً كما تفعل مثيلاتها اليوم.

 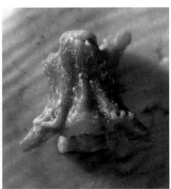 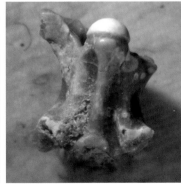

Fossils of other reptiles. Left to right: Turtle shell bone (AUH 1484) and the vertebrae of prehistoric snakes (AUH 1446, AUH 1389).

متحجرات زواحف أخرى مستخرجة. من اليسار إلى اليمين: عظمة بيت سلحفاة وفقرات ظهر أفاعي مما قبل التاريخ.

Fish

There are many remains of fish in the Baynunah sediments; most are just small scraps of the skeleton. However, even these can be most informative. Perhaps most of the fish represented are catfish of various kinds, belonging to the families Clariidae and Bagridae. Modern versions of these are abundant in slow-moving rivers and lakes today. One of these catfish has been described as a previously unknown species—*Bagrus shuwaiensis*—named after Shuwayhat Island.

Another interesting fish is the sawfish, belonging to the family Pristidae. Sawfish have a long, flattened extension to their nose that is serrated transversely, like a saw. The ray-like sawfishes today are primarily marine but are known to swim good distances up rivers.

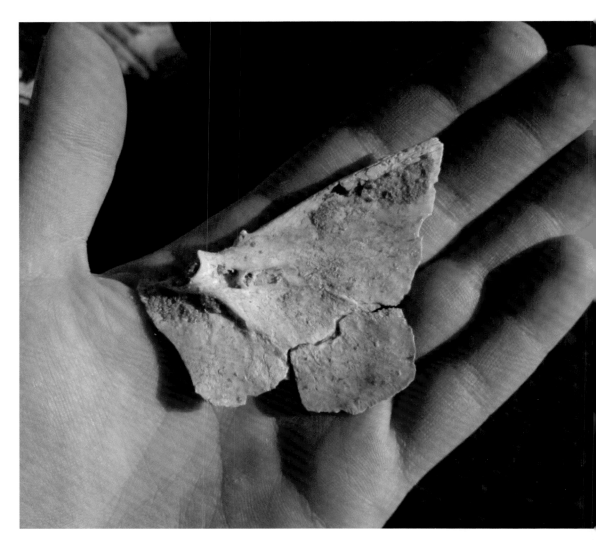

عظمة من خيشوم سمكة نهر كبيرة.

Bone from the gill area of a large river fish (AUH 1536).

الأسماك

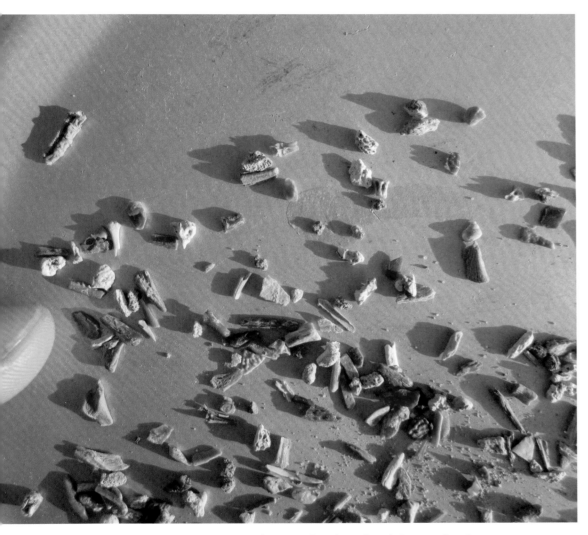

تخيل تربة مستخرجة باستعمال شبكة دقيقة يكشف عظيمات سمك صغيرة متحجرة. الشويهات، 5 يناير 2011.

Sieving excavated sand through a fine screen reveals many tiny fossilized fish bones. Shuwaihat, 5 January 2011.

وُجدت بقايا كثيرة من الأسماك في ترسبات البينونة، معظمها مجرد فتات من الهياكل العظمية. ولكن حتى هذه يمكن أن تكون غنية بالمعلومات. وقد يكون أكثر تلك الأسماك من أنواع مختلفة من أسماك السِّلور التي تنتمي إلى عائلتي «كلاريداي», «باجريداي». وتوجد أصناف معاصرة منها بوفرة اليوم في الأنهر البطيئة والبحيرات.

وقد اعتبر صنف منها غير معروف من قبل وسُمي «باغْروس شُوايْتْزيس»، على اسم جزيرة الشويهات.

السمك الآخر المثير للاهتمام هو من نوع سمك «أبو منشار» الذي ينتمي إلى عائلة «البريستيداي». ولسمك «أبو منشار» امتداد مسطح في أنفه، فيه أسنان معقوفة بشكل مستعرَض، كما أسنان المنشار. وأسماك «أبو منشار» الشبيهة بسمك السفَن اليوم تعتبر بَحرية بالدرجة الأولى لكن من المعروف أنها تسبح مسافات طويلة صعوداً عند مصاب الأنهر.

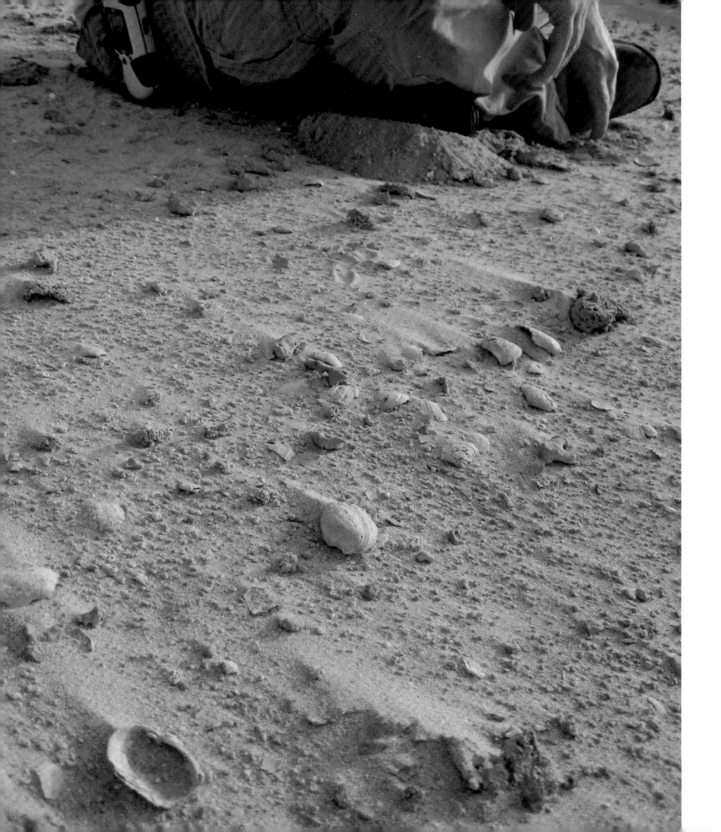

Snails and Mussels

Both snails (Gastropoda) and mussels (Bivalvia) are found fossilized in the Baynunah River sediments; several species are known. Shells of river mussels are eroding out of the rocks, relatives of which are widespread in freshwater situations at the present day. They occur in ponds, lakes, and slow- or fast-flowing rivers and streams. From their form the fossil species seem adapted to moderately fast-moving streams.

Among the Baynunah gastropods is a land snail, but there are also aquatic gastropods belonging to the family Cerithiidae, which are today found in brackish habitats. Moulds of these are found near the top of the rock section in carbonate rocks that we believe were formed in saline conditions.

محارات ماء عذب متحجرة. الحمراء، 26 ديسمبر 2007.

Fossilized freshwater mussels (Leguminaia). Hamra, 26 December 2007.

القواقع وبلح البحر

توجد متحجرات كلٍّ من القواقع وبلح البحر في ترسبات البينونة. والمعروف منها يعود إلى أنواع عدة. ويجري جرف أصداف من بلح البحر النهري خارج الصخور، وينتشر أقرباء لها اليوم في مواقع المياه الحلوة. وهي توجد في البرك والبحيرات وفي الأنهر البطيئة والسريعة والجداول. ويستدل من أشكال الأنواع المتحجرة أنها تكيّفت والجداول المتدفقة بسرعة معتدلة. ومن بين الرخويات بطنية الأقدام في البينونة هناك حلزونة برية. لكن هناك أيضاً رخويات مائية تنتمي إلى عائلة "سِيرِيتِيدا" التي تسكن اليوم في مستوطنات موَيْلحة، أو قليلة الملح. ويمكن إيجاد قوالب منها قرب رؤوس الصخور الكربونية التي نعتقد أنها تشكلت في ظروف مالحة.

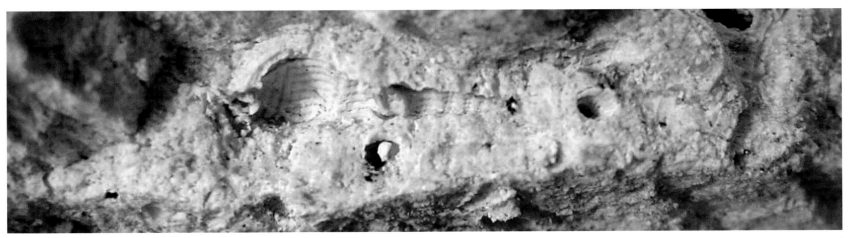

آثار متحجرة تعود إلى حلزون. الكحال، ٤ يناير ٢٠٠٩.

Fossilized imprints of small cerithid-like gastropods (snails). Kihal, 4 January 2009.

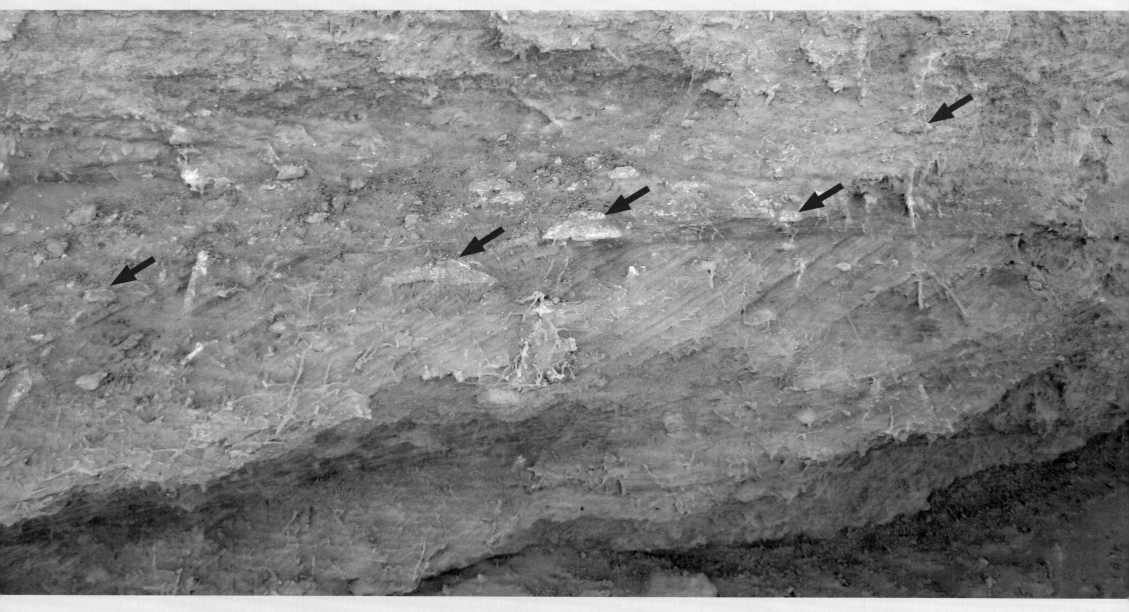

تلال نمل أبيض صغيرة وأنفاقه المتحجرة (الأسهم) منتشرة في ترسبات البينونة. جبل براكه، 5 يناير 2010.

Fossilized termite mounds and tunnels (arrows) are common in the Baynunah sediments. Jebel Barakah, 5 January 2010.

Insects

Insects are generally rare as fossils, but sometimes we can find out about them from traces and structures they left in the rock when alive. We know that there were termites in the soils around the Baynunah River, for example. Termites are colonial and construct large mounds that house their nests. These photographs shows fossilized termite nests and burrows.

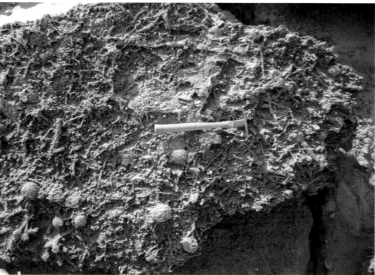

ونعرف أن نملاً أبيض وُجد في التربة حول نهر البينونة، مثلاً. والنمل الأبيض يعيش في مستوطنات وهو يبني أكواماً واسعة يقيم فيها أعشاشه. وتبدو في هذه الصور أعشاش وجحور نمل متحجرة.

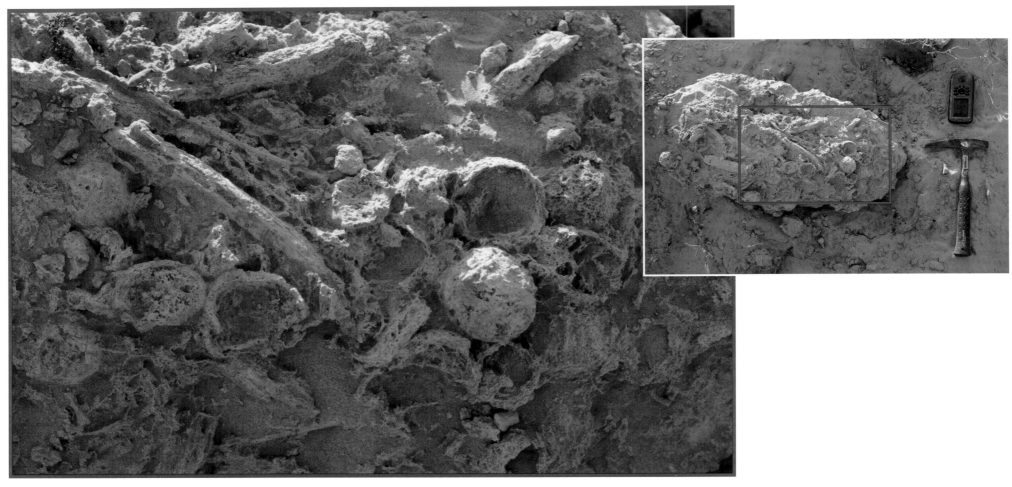

كرات متحجرة تعود إلى خنفساء الروث. الكحال، 31 ديسمبر 2007.

Fossilized dung beetle balls and vegetation (AUH 1251). Kihal, 31 December 2007.

The dung beetle (Scarabaeidae) is famous for collecting the dung of mammals and rolling it around in front of it, forming a huge round ball, larger than itself. The beetle then buries the dung ball and lays in it a fertilized egg. A grub hatches out and initially feeds on the dung that surrounds it. These structures are known as brood balls. They are quite rare in the fossil record, but we have discovered some in the sediments of the Baynunah.

الحشرات

يندر وجود الحشرات كمتحجرات غير أننا نستطيع أن نعرف عنها من الآثار والأشكال التي تركتها في الصخر عندما كانت حية. تشتهر خنفساء الروث (الجعل) بأنها تجمع روث الثدييات في كريّات وتدحرجها أمامها ما يشكل كرة ضخمة أكبر منها. ثم تدفن الخنفساء الكرة وتضع فيها بويضة مخصّبة. تفقس اليرقة وتتغذى بدايةً على الروث الذي يحيط بها. وتعرف هذه الأشكال باسم الكرة الحاضنة. وهي نادرة في سجلات المتحجرات غير أننا اكتشفنا بعضها في ترسبات البينونة.

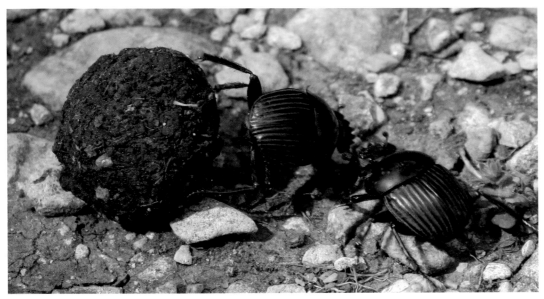

خنفساء روث (سْكَرَبيُوس لاتيكوليس).

A dung beetle (Scarabaeus laticollis).

Plants

Fossil remains of plants are generally quite rare, but we are fortunate to have some in the Baynunah Formation. They are nearly all fragments of fossilized trees. Some of them, however, are quite large in diameter and imply that they had considerable height in life.

في الصفحة المقابلة: قطعة كبيرة من الخشب المتحجر تبرز على السطح. قرين العيش، 8 يناير 2010.

Opposite page: A large chunk of fossilized wood weathers onto the surface. Gerain al-Aysh, 8 January 2010.

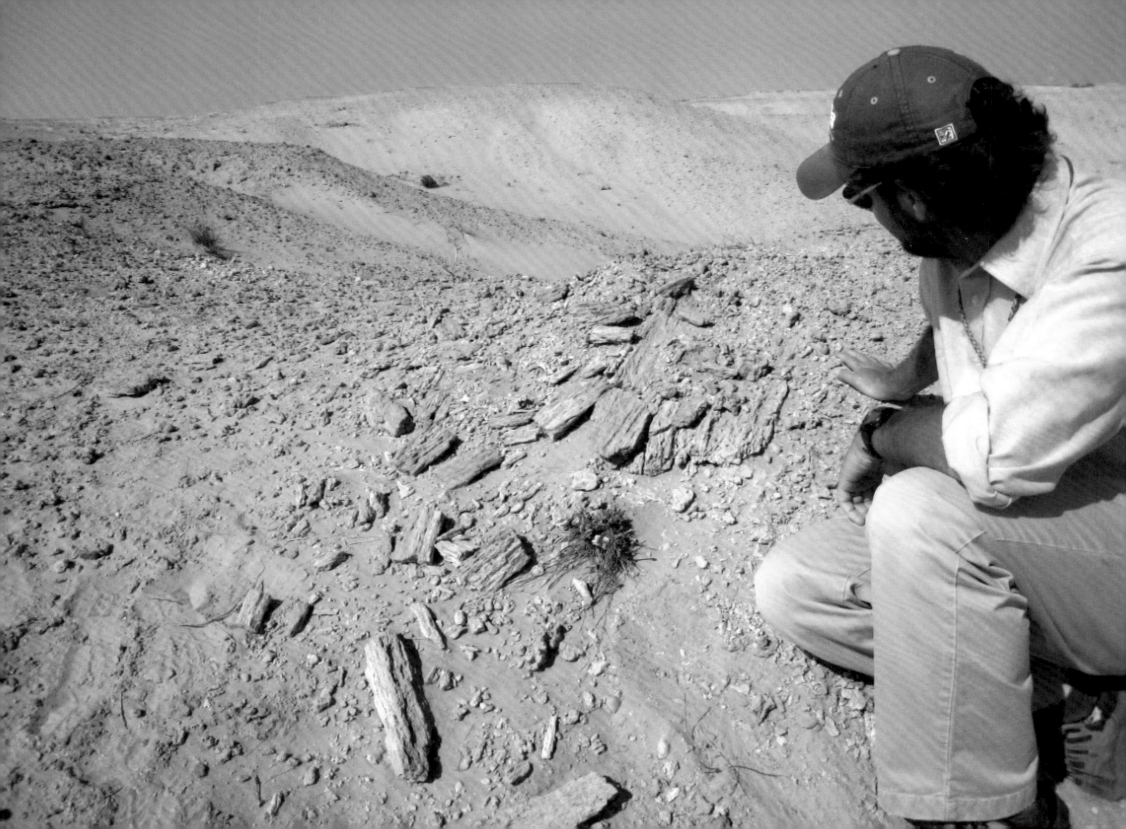

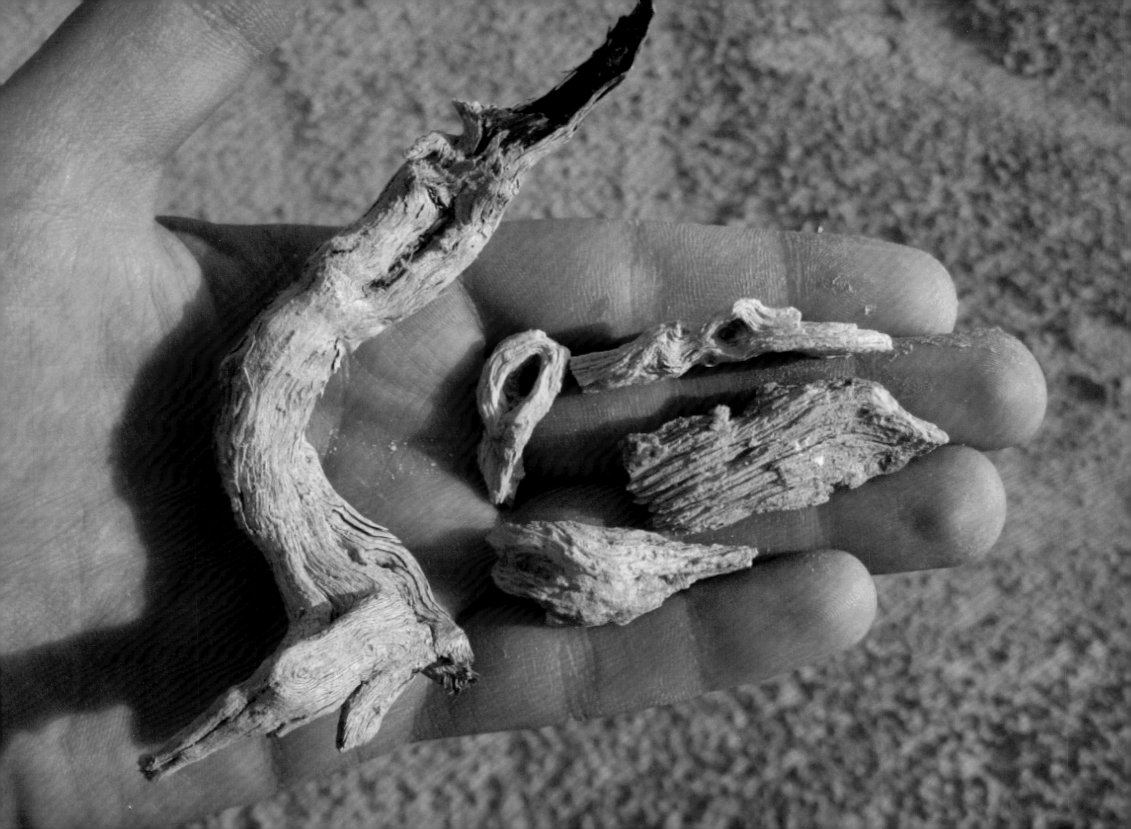

النباتات

متحجرات بقايا النباتات نادرة جداً لكن هناك بعضاً منها في تشكيل البينونة لحسن الحظ. وكلها تقريباً شظايا من أشجار متحجرة. غير أن بعضها ذو قطر كبير ما يعني ضمناً أن ارتفاعها كان كبيراً.

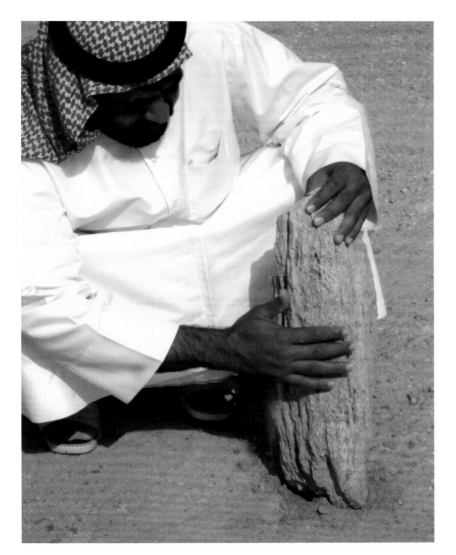

عضو في الفريق يتفحص قطعة كبيرة من الخشب المتحجر. الحضوانية، 11 يناير 2010.

A member of the team inspects a large chunk of fossilized wood. Hadwaniya, 11 January 2010.

الصورة المقابلة: القطعة اليسرى هي جزء من نبتة خشبية تنمو اليوم في الغربية. إلى اليمين: قطع من الخشب المتحجر عمرها نحو 7 ملايين سنة من المنطقة ذاتها. الحضوانية، يناير 2010.

Opposite page: To the left, a fragment of a woody plant that grows today in Al Gharbia. At right, pieces of fossilized wood around 7 million years old from the same area (AUH 1583). Hadwaniya, January 2010.

Summary

Some of the fossil animals found in the Baynunah Formation are of great interest, especially within the Emirates but also from the point of view of Arabia as a whole, and indeed internationally. They have proved highly interesting within the Emirates to people keenly interested in the land and its history, and the discoveries have always provoked considerable media coverage.

The Baynunah fauna is the only collection of mammalian fossils known in the whole of Arabia between about 14 million and 1 million years ago, and provides our only opportunity to know what was happening in this large region of the world at a time when the Old World mammalian fauna was evolving and taking on its modern character. Arabia was always important in this process, as it is at the junction of the great Old World biogeographic zones of Africa, Asia, and Europe and formed a corridor through which creatures may have expanded from one zone to another. Arabia, and the nature of its past environments, has exerted a certain amount of control over the nature of the mammalian fauna of the Old World.

The fossil sites remain productive, and it is hoped that they will be fully protected for future generations. It is important that the collections be housed in a facility that will reveal these remnants of the past to the general public and also will encourage scientific study, so that we may know more about them and what they tell us about the remote past of Abu Dhabi Emirate.

الصورة المقابلة: الحمراء 5، 4 يناير 2008.

Opposite page: Hamra 5, 4 January 2008.

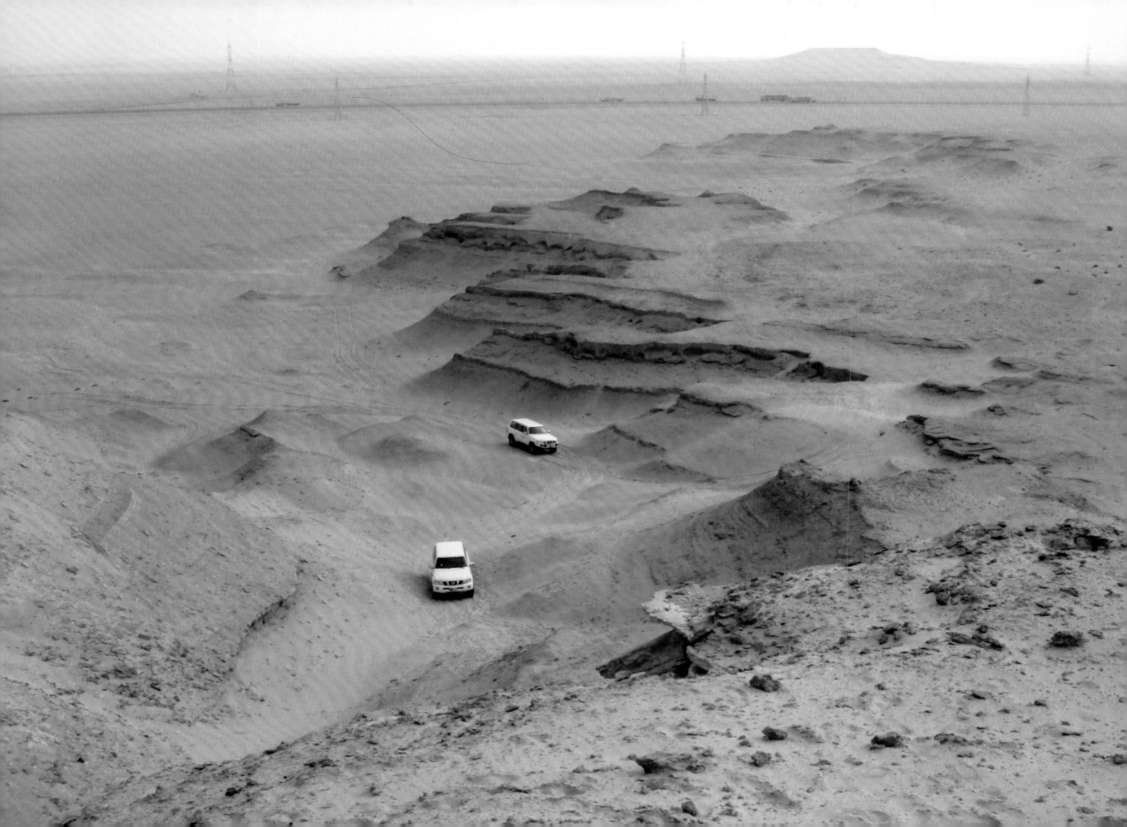

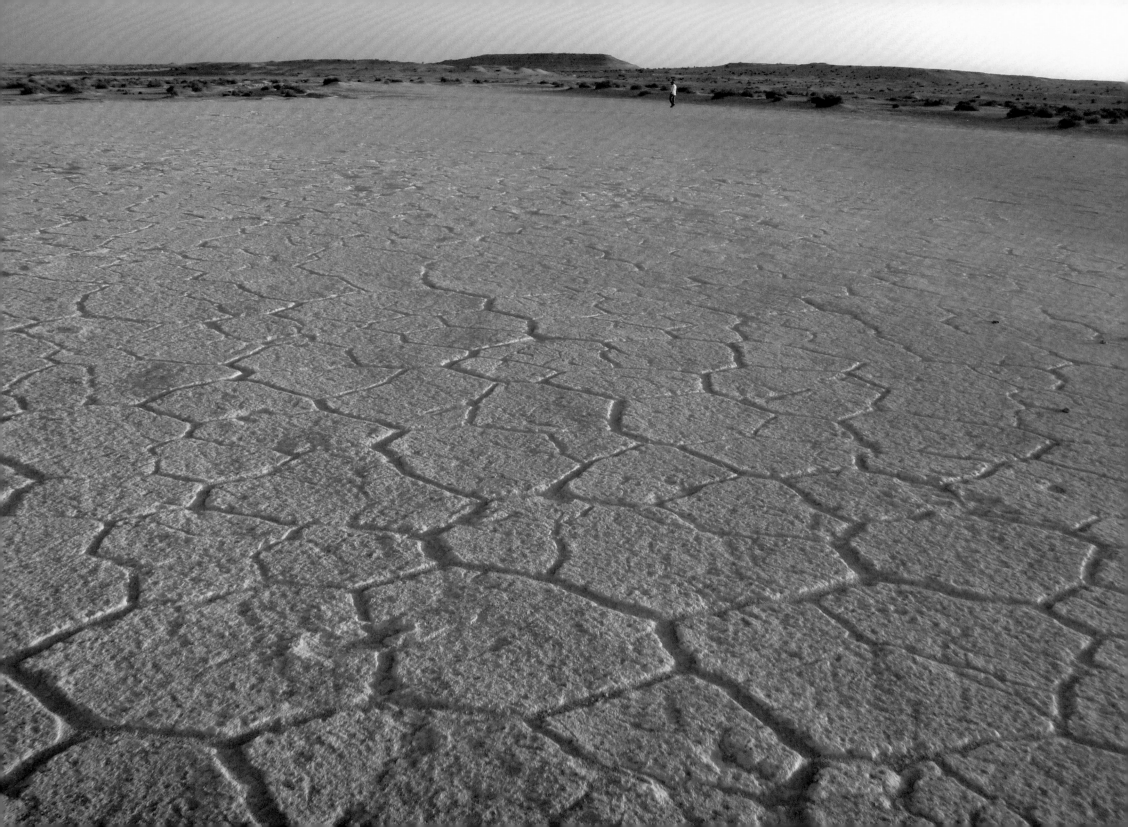

تقديم

كيف لنا أن نعرف أي شيء عن الحيوانات التي عاشت في الماضي السحيق وعن البيئات التي عاشت فيها؟ إذ ما أن تموت حتى تمزقها الحيوانات اللواحم، آكلة اللحوم، فيما تتعفن بقاياها وتختفي كلياً في نهاية المطاف. غير أننا نجد بين الحين والآخر بقايا حيوانات ماتت قبل زمن طويل ولكنها بقيت محفوظة متحجرة لملايين من السنين ما يتيح لنا لمحات عن الحياة الغابرة.

أحد الأماكن المهمة التي وجدت فيها مثل هذه المتحجرات يقع في صحراء إمارة أبو ظبي، وبشكل رئيسي على طول ساحل الغربية، في صخور تسمى تشكيل البينونة. هناك ظهرت براهين على حيوانات كثيرة بما في ذلك كثير من الحيوانات التي لا تعيش في المنطقة اليوم بل سيكون من المستغرب أن تعيش فيها أصلاً. إنها حيوانات ترتبط ببيئات مختلفة كالفيلة وفراس النهر والظباء والزرافات والخنازير والقردة وغيرها الكثير.

وهذه حكايتها.

الصورة المقابلة: قرب مليسة ١٠، ١٣ يناير ٢٠١١.

Opposite page: Near Mleisa 1, 13 January 2011.

Acknowledgments

Many people and agencies have assisted with the paleontological exploration of Al Gharbia over the decades. Primarily we wish to thank the Historic Environment Department of the Abu Dhabi Tourism and Culture Authority (TCA Abu Dhabi; formerly the Abu Dhabi Authority for Culture and Heritage, or ADACH), which encourages and sustains our work on the Baynunah fossils and their ecological context. The suggestion for this book came from His Excellency Mohammed Khalaf Al Mazrouei, when Director General of the ADACH, and since then the project has been financed by TCA Abu Dhabi and supported by Jumaa Al Qubaisi, Director of the National Library. Additional images, beyond the authors' own, were provided by Mauricio Anton and Brian Kraatz. Ghanem Bibi provided the Arabic translation.

امتنان

على مدى عقود، ساعد الكثير من الناس والمؤسسات في استكشاف "الغربية" أحفورياً. ونود بشكل خاص أن نشكر دائرة التاريخ البيئي في هيئة السياحة والثقافة (هيئة أبو ظبي للثقافة والتراث سابقاً) التي تشجع عملنا على متحجرات البينونة، وتموله. اقتراح هذا الكتاب جاء من سعادة السيد محمد خلف المزروعي وقتَ كان المدير العام للهيئة. ومذّاك تمول المشروع هيئة السياحة والثقافة، ويدعمه مدير الكتبة الوطنية السيد جمعة القبيسي. وفضلاً عن الصور بعدسة المؤلفين فقد وفر الصور الإضافية ماوْرِيتْشيو أنطون وبْرايان كراتس. ووفر الترجمة غانم بيبي.

الصورة المقابلة: جبل الظنة، 12 ديسمبر 2006.

Opposite page: Jebel Dhanna, 12 December 2006.

A Brief History of Paleontological Exploration in Abu Dhabi

Left to right:
Shuwaihat, December 2014;
Mleisa 1, January 2011;
Mleisa, January 2010;
Shuwaihat, January 2009.

الشويهات، ديسمبر ٢٠١٤. مليسة ١، يناير ٢٠١١. مليسة، يناير ٢٠١٠. الشويهات، يناير ٢٠٠٩.

Fossils have been scientifically known from Al Gharbia since the days of early exploration for oil, going back to 1949, when fossils were noted by field geologists. Peter Whybrow, of the Natural History Museum, London, followed up their work in a series of visits starting in 1979, when he focused on the site of Jebel Barakah.

A breakthrough of a kind occurred in 1983, when an archaeological survey headed by Burkhardt Vogt found additional Miocene fossils at new sites along the coast. In 1984 Andrew Hill was invited to Abu Dhabi to help evaluate them, and in a short visit to the west he and Walid Yasin al-Tikriti, then of the former Department of Tourism and Antiquities, Al Ain, discovered more occurrences. Between 1989 and 1995 Hill, Whybrow, and Yasin al-Tikriti collaborated on an extensive project that led to the First International Conference on the Fossil Vertebrates of Arabia, held at Jebel Dhanna in March 1995. The conference resulted in the publication of the monograph *Fossil Vertebrates of Arabia* (Yale University Press) in 1999.

Additional work was subsequently carried out by Mark Beech and a team directed by Peter Hellyer as part of the Abu Dhabi Islands Archaeological Survey between 2002 and 2006, and also by Faysal Bibi, who led an expedition in 2003 with the support of the Abu Dhabi Works Department.

In 2006 the Abu Dhabi Authority for Culture and Heritage (ADACH; now the Abu Dhabi Tourism and Culture Authority) invited Hill and Bibi to Abu Dhabi to help evaluate the sites in collaboration with Beech and Yasin al-Tikriti of ADACH. This began another five-year project in the area, which is now extended. This book is part of that ongoing work.

الاستكشاف الأحفوري في أبوظبي: تاريخ موجز

Left to right:
Ras al Qal'a, December 2008;
Shuwaihat, December 2007;
Jaw Al Dibsa, December 2006.

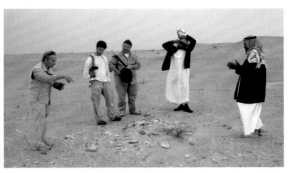

راس القلعة، ديسمبر 2008.

الشويهات، ديسمبر 2007.

جو الدبسة، ديسمبر 2006.

من الناحية العلمية، عُرفت متحجرات "الغربية" منذ أعمال استكشاف النفط المبكرة التي تعود إلى العام 1949، إذ لاحظها علماء الحقل الجيولوجيون. وقد تابع أعمالهم بيتَر وايْبْراو، من متحف التاريخ الطبيعي في لندن، من خلال سلسلة من الزيارات التي بدأت عام 1979، مركَّزاً على جبل براكة.

في العام 1983، حدث نوع من الاختراق حينما وجد مسح آركيولوجي بقيادة بوزْكازْدْت فوكت، مزيداً من المتحجرات الميوسينية في مواقع جديدة على امتداد الساحل. وفي عام 1984 وُجهت الدعوة إلى أندرو هيْل لزيارة أبوظبي والمساعدة على تثمين المتحجرات. وفي زيارة قصيرة إلى المنطقة الغربية قام بها هو ووليد ياسين التكريتي من دائرة السياحة والآثار سابقاً، وجدا أماكن متحجرات أكثر. وما بين 1989 و1995، تعاون هيل ووايْبْرو وياسين التكريتي في مشروع موسع أدى إلى أول مؤتمر عالمي عن أحفوريات الفقاريات في الجزيرة العربية. عقد المؤتمر في جبل الظنة في مارس/آذار من العام 1995 ونتج عنه كتاب "فقاريات الجزيرة العربية المتحجرة" الذي نشرته دار جامعة يال (Fossil Vertebrates of Arabia. Yale University Press, 1999).

في أعقاب ذلك، جاءت أعمال أخرى على يد كلٍ من مارْك بيْتْش وفريق بقيادة بيْتَر هِيلْيَر كجزء من "المسح الأركيولوجي لجزر أبوظبي" بين 2002 و2006، وكذلك على يد فيصل بيبي الذي قاد فريق استكشاف في بدعم من دائرة أشغال ابو ظبي 2003.

في عام 2006 وجهت هيئة الثقافة والتراث (التي باتت اليوم هيئة أبوظبي للسياحة والثقافة) دعوة إلى أندرو هيل وفيصل بيبي لزيارة أبوظبي والمساعدة على تقدير المواقع بالتعاون مع مارك بيتْش ووليد ياسين التكريتي من الهيئة. وكانت تلك فاتحة مشروع آخر لخمس سنوات في المنطقة، جرى تمديده لاحقا. هذا الكتاب هو جزء من ذاك العمل المتواصل.

Further Reading

A Complete Bibliography Concerning the Fossils and Paleoenvironments of the Baynunah Formation, Al Gharbia, United Arab Emirates

قراءات مزيدة:

هذه بيبلوغرافيا شاملة للأحفوريات والبيئات الإحاثية في تشكيل البينونة، الغربية، الإمارات العربية المتحدة.

Andrews, P. 1999. Taphonomy of the Shuwaihat Proboscidean, Late Miocene, Emirate of Abu Dhabi, United Arab Emirates. In: Whybrow, P.J. and Hill, A. (eds.), *Fossil Vertebrates of Arabia: With Emphasis on the Late Miocene Faunas, Geology, and Palaeoenvironments of the Emirate of Abu Dhabi, United Arab Emirates*. New Haven: Yale University Press, pp. 338–353.

Barry, J.C. 1999. Late Miocene carnivora from the Emirate of Abu Dhabi, United Arab Emirates. In: Whybrow, P.J. and Hill, A. (eds.), *Fossil Vertebrates of Arabia: With Emphasis on the Late Miocene Faunas, Geology, and Palaeoenvironments of the Emirate of Abu Dhabi, United Arab Emirates*. New Haven: Yale University Press, pp. 203–208.

Beech, M. 2005a. Appendix 1: Catalogue of fossils in the exhibition "Abu Dhabi 8 Million Years Ago: Fossils from the Western Region." In: Beech, M. and Hellyer, P. (eds.), *Abu Dhabi 8 Million Years Ago: Late Miocene Fossils from the Western Region*. Abu Dhabi: Abu Dhabi Islands Archaeological Survey, pp. 43–55.

Beech, M. 2005b. The late Miocene fossil site at Ruwais. In: Beech, M. and Hellyer, P. (eds.), *Abu Dhabi 8 Million Years Ago: Late Miocene Fossils from the Western Region*. Abu Dhabi: Abu Dhabi Islands Archaeological Survey, pp. 21–33.

Beech, M. and Hellyer, P. (eds.). 2005. *Abu Dhabi 8 Million Years Ago: Late Miocene Fossils from the Western Region*. Abu Dhabi: Abu Dhabi Islands Archaeological Survey.

Beech, M. and Higgs, W. 2005. A new late Miocene fossil site in Ruwais, Western Region of Abu Dhabi, United Arab Emirates. In: Hellyer, P. and Ziolkowski, M. (eds.), *Emirates Heritage. Vol. 1*. Abu Dhabi: Zayed Centre for Heritage and History, pp. 6–21.

Bibi, F. 2011. Mio-Pliocene faunal exchanges and African biogeography: The record of fossil bovids. *PLoS ONE* 6(2): e16688. doi:10.1371/journal.pone.0016688.

Bibi, F., Hill, A., Beech, M. and Yasin, W. 2008. A river fauna from the Arabian Desert: Late Miocene fossils from the United Arab Emirates. *Journal of Vertebrate Paleontology* 28(3): 53A.

Bibi, F., Hill, A., Beech, M. and Yasin, W. 2013. Late Miocene fossils from the Baynunah Formation, United Arab Emirates: Summary of a decade of new work. In: Wang, X., Flynn, L.J. and Fortelius, M. (eds.), *Fossil Mammals of Asia: Neogene Biostratigraphy and Chronology*. New York: Columbia University Press, pp. 583–594.

Bibi, F., Kraatz, B., Craig, N., Beech, M. and Hill, A. 2012. Complex social structure in Proboscidea from a remarkable late Miocene trackway site in the United Arab Emirates. *Journal of Vertebrate Paleontology*, Annual Meeting Abstracts: 63–64.

Bibi, F., Kraatz, B., Craig, N., Beech, M., Schuster, M. and Hill, A. 2012. Early evidence for complex social structure in Proboscidea from a late Miocene trackway site in the United Arab Emirates. *Biology Letters* 8(4): 670–673. doi:10.1098/rsbl.2011.1185.

Bibi, F., Shabel, A.B., Kraatz, B.P. and Stidham, T.A. 2006. New fossil ratite (Aves: Palaeognathae) eggshell discoveries from the Late Miocene Baynunah Formation of the United Arab Emirates, Arabian Peninsula. *Palaeontologia Electronica* 9 (1); 2A: 1–13. http://palaeo-electronica.org/paleo/2006_1/eggshell/issue1_06.htm

Bishop, L. and Hill, A. 1999. Fossil Suidae from the Baynunah Formation, Emirate of Abu Dhabi, United Arab Emirates. In: Whybrow, P.J. and Hill, A. (eds.), *Fossil Vertebrates of Arabia: With Emphasis on the Late Miocene Faunas, Geology, and Palaeoenvironments of the Emirate of Abu Dhabi, United Arab Emirates*. New Haven: Yale University Press, pp. 254–270.

Bown, T. and Genise, J.F. 1993. Fossil nests and gallery systems of termites (Isoptera) and ants (Formicidae) from the early Miocene of Southern Ethiopia and the late Miocene of Abu Dhabi Emirate, U.A.E. *Geological Society of America*, Meeting Abstracts: 25, A58.

Bristow, C.S. 1999. Aeolian and sabkha sediments in the Miocene Shuwaihat Formation, Emirate of Abu Dhabi, United Arab Emirates. In: Whybrow, P.J. and Hill, A. (eds.), *Fossil Vertebrates of Arabia: With Emphasis on the Late Miocene Faunas, Geology, and Palaeoenvironments of the Emirate of Abu Dhabi, United Arab Emirates*. New Haven: Yale University Press, pp. 50–60.

Bristow, C.S. and Hill, N. 1998. Dune morphology and palaeowinds from aeolian sandstones in the Miocene Shuwaihat Formation, Abu Dhabi, United Arab Emirates. In: Alsharhan, A.S., Glennie, K.W., Whittle G.L. and Kendall, C.G.St.C. (eds.), *Quaternary Deserts and Climatic Change*. Rotterdam: Balkema, pp. 553–564.

Broin, F. de and van Dijk, P.P. 1999. Chelonia from the late Miocene Baynunah Formation, Emirate of Abu Dhabi, United Arab Emirates: Paleogeographic implications. In: Whybrow, P.J. and Hill, A. (eds.), *Fossil Vertebrates of Arabia: With Emphasis on the Late Miocene Faunas, Geology, and Palaeoenvironments of the Emirate of Abu Dhabi, United Arab Emirates*. New Haven: Yale University Press, pp. 136–162.

de Bruijn, H. 1999. A Late Miocene insectivore and rodent faunas from the Baynunah Formation, Emirate of Abu Dhabi, United Arab Emirates. In: Whybrow, P.J. and Hill, A. (eds.), *Fossil Vertebrates of Arabia: With Emphasis on the Late Miocene Faunas, Geology, and Palaeoenvironments of the Emirate of Abu Dhabi, United Arab Emirates*. New Haven: Yale University Press, pp. 186–197.

de Bruijn, H. and Whybrow, P.J. 1994. A Late Miocene rodent fauna from the Baynunah Formation, Emirate of Abu Dhabi, United Arab Emirates. *Proceedings Koninklijke Nederlandse Akademie van Wetenschappen* 97: 407–422.

Eisenmann, V. and Whybrow, P.J. 1999. Hipparions from the late Miocene Baynunah Formation, Emirate of Abu Dhabi, United Arab Emirates. In: Whybrow, P.J. and Hill, A. (eds.), *Fossil Vertebrates of Arabia: With Emphasis on the Late Miocene Faunas, Geology, and Palaeoenvironments of the Emirate of Abu Dhabi, United Arab Emirates*. New Haven: Yale University Press, pp. 234–253.

Flynn, L.J. and Jacobs, L.L. 1999. Late Miocene small-mammal faunal dynamics: The crossroads of the Arabian peninsula. In: Whybrow, P.J. and Hill, A. (eds.), *Fossil Vertebrates of Arabia: With Emphasis on the Late Miocene Faunas, Geology, and Palaeoenvironments of the Emirate of Abu Dhabi, United Arab Emirates*. New Haven: Yale University Press, pp. 412–419.

Forey, P.L. and Young, S.V.T. 1999. Late Miocene fishes of the Emirate of Abu Dhabi, United Arab Emirates. In: Whybrow, P.J. and Hill, A. (eds.), *Fossil Vertebrates of Arabia: With Emphasis on the Late Miocene Faunas, Geology, and Palaeoenvironments of the Emirate of Abu Dhabi, United Arab Emirates*. New Haven: Yale University Press, pp. 120–135.

Fox, M., Bibi, F. and Hill, A. 2008. Jacketing the desert sands. *Journal of Vertebrate Paleontology* 28(3): 80A.

Friend, P.F. 1999. Rivers of the lower Baynunah Formation, Emirate of Abu Dhabi, United Arab Emirates. In: Whybrow, P.J. and Hill, A. (eds.), *Fossil Vertebrates of Arabia: With Emphasis on the Late Miocene Faunas, Geology, and Palaeoenvironments of the Emirate of Abu Dhabi, United Arab Emirates*. New Haven: Yale University Press, pp. 39–49.

Gee, H. 1989. Fossils from the Miocene of Abu Dhabi. *Nature* 338: 704.

Gentry, A.W. 1999a. A fossil hippopotamus from the Emirate of Abu Dhabi, United Arab Emirates. In: Whybrow, P.J. and Hill, A. (eds.), *Fossil Vertebrates of Arabia: With Emphasis on the Late Miocene Faunas, Geology, and Palaeoenvironments of the Emirate of Abu Dhabi, United Arab Emirates*. New Haven: Yale University Press, pp. 271–289.

Gentry, A.W. 1999b. Fossil pecorans from the Baynunah Formation, Emirate of Abu Dhabi, United Arab Emirates. In: Whybrow, P.J. and Hill, A. (eds.), *Fossil Vertebrates of Arabia: With Emphasis on the Late Miocene Faunas, Geology, and Palaeoenvironments of the Emirate of Abu Dhabi, United Arab Emirates*. New Haven: Yale University Press, pp. 290–316.

Gilbert, C., Bibi, F., Hill, A., Beech, M. and Rossie, J.B. 2013. Early Old World monkeys from Africa and Arabia: Implications for the origins and biogeography of major cercopithecid clades. *Journal of Vertebrate Paleontology*, Annual Meeting Abstracts: 134.

Glennie, K.W. and Evamy, B.D. 1968. Dikaka: Plants and plant-root structure associated with aeolian sand. *Palaeogeography, Palaeoclimatology, Palaeoecology* 4: 77–87.

Goodall, G. and Larkin, N. 2005. Appendix 3: The reconstruction painting—"Abu Dhabi 8 million years ago." In: Beech, M. and Hellyer, P. (eds.), *Abu Dhabi 8 Million Years Ago: Late Miocene Fossils from the Western Region*. Abu Dhabi: Abu Dhabi Islands Archaeological Survey, pp. 60–62.

Hadley, D.G., Bown, T.M. and Brouwers, E.M. 1992. Late Miocene fluvial and shallow marine paleoenvironments, central and western Abu Dhabi Emirate, United Arab Emirates. *Geological Society of America*, Meeting Abstracts: 24, A360.

Hafeez, A., Hafeez, I. and Beech, M. 2005. Appendix 2: Constructing the scale model of *Stegotetrabelodon syrticus*. In: Beech, M. and Hellyer, P. (eds.), *Abu Dhabi 8 Million Years Ago: Late Miocene Fossils from the Western Region*. Abu Dhabi: Abu Dhabi Islands Archaeological Survey, pp. 56–59.

Hailwood, E.A. and Whybrow, P.J. 1999. Palaeomagnetic correlation and dating of the Baynunah and Shuwaihat Formations, Emirate of Abu Dhabi, United Arab Emirates. In: Whybrow, P.J. and Hill, A. (eds.), *Fossil Vertebrates of Arabia: With Emphasis on the Late Miocene Faunas, Geology, and Palaeoenvironments of the Emirate of Abu Dhabi, United Arab Emirates*. New Haven: Yale University Press, pp. 75–87.

Hellyer, P. 2002. Newly discovered coastal and island archaeological sites in northeast Abu Dhabi. *Tribulus* 12(2): 5–11.

Higgs, W. 2005. The fossil trackway at Mleisa. In: Beech, M. and Hellyer, P. (eds.), *Abu Dhabi 8 Million Years Ago: Late Miocene Fossils from the Western Region*. Abu Dhabi: Abu Dhabi Islands Archaeological Survey, pp. 37–41.

Higgs, W., Gardner, D. and Beech, M. 2005. A fossil proboscidean trackway at Mleisa, Western Region of Abu Dhabi, United Arab Emirates. In: Hellyer, P. and Ziolkowski, M. (eds.), *Emirates Heritage. Vol. 1*. Abu Dhabi: Zayed Centre for Heritage and History, pp. 22–28.

Higgs, W., Kirkham, A., Evans, G. and Hull, D. 2003. A Late Miocene proboscidean trackway from Mleisa, United Arab Emirates. *Tribulus* 13(2): 3–8.

Hill, A. 1999. Late Miocene sub-Saharan vertebrates, and their relation to the Baynunah fauna, Abu Dhabi, United Arab Emirates. In: Whybrow, P.J. and Hill, A. (eds.), *Fossil Vertebrates of Arabia: With Emphasis on the Late Miocene Faunas, Geology, and Palaeoenvironments of the Emirate of Abu Dhabi, United Arab Emirates*. New Haven: Yale University Press, pp. 420–429.

Hill, A. 2012. The family life of fossils: Fossil elephant trackways in the desert of Abu Dhabi. *Yale Environmental Newsletter* 17(2): 16–17.

Hill, A., Bibi, F., Beech, M. and Yasin al-Tikriti, W. 2012. Before archaeology: Life and environments in the Miocene of Abu Dhabi. In: Potts, D.T. and Hellyer, P. (eds.), *Fifty Years of Emirates Archaeology*. Abu Dhabi: Ministry of Culture, Youth and Community Development, pp. 20–33.

Hill, A. and Gundling, T. 1999. A monkey (Primates; Cercopithecidae) from the Late Miocene of Abu Dhabi, United Arab Emirates. In: Whybrow, P.J. and Hill, A. (eds.), *Fossil Vertebrates of Arabia: With Emphasis on the Late Miocene Faunas, Geology, and Palaeoenvironments of the Emirate of Abu Dhabi, United Arab Emirates*. New Haven: Yale University Press, pp. 198–202.

Hill, A. and Whybrow, P.J. 1999. Summary and overview of the Baynunah Fauna, Emirate of Abu Dhabi, and its context. In: Whybrow, P.J. and Hill, A. (eds.), *Fossil Vertebrates of Arabia: With Emphasis on the Late Miocene Faunas, Geology, and Palaeoenvironments of the Emirate of Abu Dhabi, United Arab Emirates*. New Haven: Yale University Press, pp. 7–14.

Hill, A., Whybrow, P.J. and Yasin al-Tikriti, W. 1990. Late Miocene Primate fauna from the Arabian Peninsula: Abu Dhabi, United Arab Emirates. *American Journal of Physical Anthropology* 81: 240–241.

Hill, A., Whybrow, P.J. and Yasin, W. 1999. History of palaeontological research in the Western Region of the Emirate of Abu Dhabi, United Arab Emirates. In: Whybrow, P.J. and Hill, A. (eds.), *Fossil Vertebrates of Arabia: With Emphasis on the Late Miocene Faunas, Geology, and Palaeoenvironments of the Emirate of Abu Dhabi, United Arab Emirates*. New Haven: Yale University Press, pp. 15–23.

Jeffrey, P.A. 1999. Late Miocene swan mussels from the Baynunah Formation, Emirate of Abu Dhabi, United Arab Emirates. In: Whybrow, P.J. and Hill, A. (eds.), *Fossil Vertebrates of Arabia: With Emphasis on the Late Miocene Faunas, Geology, and Palaeoenvironments of the Emirate of Abu Dhabi, United Arab Emirates*. New Haven: Yale University Press, pp. 111–115.

Kingston, J.D. 1999. Isotopes and environments of the Baynunah Formation, Emirate of Abu Dhabi, United Arab Emirates. In: Whybrow, P.J. and Hill, A. (eds.), *Fossil Vertebrates of Arabia: With Emphasis on the Late Miocene Faunas, Geology, and Palaeoenvironments of the Emirate of Abu Dhabi, United Arab Emirates*. New Haven: Yale University Press, pp. 354-372.

Kingston, J.D. and Hill, A. 1999. Late Miocene palaeoenvironments in Arabia: A synthesis. In: Whybrow, P.J. and Hill, A. (eds.), *Fossil Vertebrates of Arabia: With Emphasis on the Late Miocene Faunas, Geology, and Palaeoenvironments of the Emirate of Abu Dhabi, United Arab Emirates*. New Haven: Yale University Press, pp. 389-407.

Kraatz, B., Bibi, F. and Hill, A. 2009. New rodents from the Late Miocene of the United Arab Emirates. *Journal of Vertebrate Paleontology* 29 (3): 129A.

Kraatz, B., Bibi, F., Hill, A. and Beech, M. 2013. A new fossil thryonomyid (Rodentia: Thryonomyidae) from the Late Miocene of the United Arab Emirates and the origin of African cane rats. *Naturwissenschaften* 100(5): 437-449. doi:10.1007/s00114-013-1043-4.

Larkin, N. 2005. Conservation of Late Miocene fossils from Abu Dhabi. In: Beech, M. and Hellyer, P. (eds.), *Abu Dhabi 8 Million Years Ago: Late Miocene Fossils from the Western Region*. Abu Dhabi: Abu Dhabi Islands Archaeological Survey, pp. 34-36.

Madden, C.T., Glennie, K.W., Dehm, R., Whitmore, F.C., Schmidt, R.J., Ferfoglia, R.J. and Whybrow, P.J. 1982. *Stegotetrabelodon* (Proboscidea, Gomphotheriidae) from the Miocene of Abu Dhabi. *Jiddah: United States Geological Survey*.

Mordan, P.B. 1999. A terrestrial pulmonate gastropod from the late Miocene Baynunah Formation, Emirate of Abu Dhabi, United Arab Emirates. In: Whybrow, P.J. and Hill, A. (eds.), *Fossil Vertebrates of Arabia: With Emphasis on the Late Miocene Faunas, Geology, and Palaeoenvironments of the Emirate of Abu Dhabi, United Arab Emirates*. New Haven: Yale University Press, pp. 116-119.

Peebles, R.G. 1999. Stable isotope analyses and dating of the Miocene of the Emirate of Abu Dhabi, United Arab Emirates. In: Whybrow, P.J. and Hill, A. (eds.), *Fossil Vertebrates of Arabia: With Emphasis on the Late Miocene Faunas, Geology, and Palaeoenvironments of the Emirate of Abu Dhabi, United Arab Emirates*. New Haven: Yale University Press, pp. 88-105.

Rauhe, M., Frey, E., Pemberton, D.S. and Rossman, T. 1999. Fossil crocodilians from the Late Miocene Baynunah Formation, Emirate of Abu Dhabi, United Arab Emirates. In: Whybrow, P.J. and Hill, A. (eds.), *Fossil Vertebrates of Arabia: With Emphasis on the Late Miocene Faunas, Geology, and Palaeoenvironments of the Emirate of Abu Dhabi, United Arab Emirates*. New Haven: Yale University Press, pp. 163-185.

Schuster, M., Bibi, F., Beech, M., Kraatz, B., Craig, N. and Hill, A. 2011. Aperçu des systèmes sédimentaires continentaux du Néogène d'Abu Dhabi (Émirats Arabes Unis): exemple des séries fossilifères à vertébrés continentaux du Miocène supérieur. *13ème Congrès Français de Sédimentologie* (ASF), Dijon (14-16/11/2011) Livre des résumés 68, pp. 306-307.

Stewart, J. 2005. Miocene geology and fossils of Abu Dhabi. In: Beech, M. and Hellyer, P. (eds.), *Abu Dhabi 8 Million Years Ago: Late Miocene Fossils from the Western Region*. Abu Dhabi: Abu Dhabi Islands Archaeological Survey, pp. 14-20.

Stewart, J. and Beech, M. 2006. The Miocene birds of Abu Dhabi (United Arab Emirates) with a discussion of the age of modern species and genera. *Historical Biology* 18(2): 103-113.

Tassy, P. 1999. Miocene Elephantids (Mammalia) from the Emirate of Abu Dhabi, United Arab Emirates: Palaeobiological implications. In: Whybrow, P.J. and Hill, A. (eds.), *Fossil Vertebrates of Arabia: With Emphasis on the Late Miocene Faunas, Geology, and Palaeoenvironments of the Emirate of Abu Dhabi, United Arab Emirates*. New Haven: Yale University Press, pp. 209-233.

Vogt, B., Gockel, W., Hofbauer, H. and Al-Haj, A.A. 1989. The coastal survey in the Western Province of Abu Dhabi. *Archaeology in the United Arab Emirates* 5: 49-60.

Whybrow, P.J. 1984. Geological and faunal evidence from Arabia for mammal "migrations" between Asia and Africa during the Early Miocene. *Courier Forschunginstitut Senckenburg* 69: 189-198.

Whybrow, P.J. 1989. New stratotype; the Baynunah Formation (Late Miocene), United Arab Emirates: Lithology and palaeontology. *Newsletters on Stratigraphy* 21: 1–9.

Whybrow, P.J. 2003. Brains in Abu Dhabi's desert. In: Whybrow, P. (ed.), *Travels with the Fossil Hunters*. Cambridge: Cambridge University Press.

Whybrow, P.J. and Bassiouni, M.A. 1986. The Arabian Miocene: Rocks, fossils, primates and problems. In: Else, J.G. and Lee, P.C. (eds.), *Primate Evolution*. Cambridge: Cambridge University Press, pp. 85–91.

Whybrow, P.J. and Clements, D. 1999. Arabian Tertiary fauna, flora, and localities. In: Whybrow, P.J. and Hill, A. (eds.), *Fossil Vertebrates of Arabia: With Emphasis on the Late Miocene Faunas, Geology, and Palaeoenvironments of the Emirate of Abu Dhabi, United Arab Emirates*. New Haven: Yale University Press, pp. 317–333.

Whybrow, P.J., Friend, P.F., Ditchfield, P.W. and Bristow, C.S. 1999. Local stratigraphy of the Neogene outcrops of the coastal area: Western Region, Emirate of Abu Dhabi, United Arab Emirates. In: Whybrow, P.J. and Hill, A. (eds.), *Fossil Vertebrates of Arabia: With Emphasis on the Late Miocene Faunas, Geology, and Palaeoenvironments of the Emirate of Abu Dhabi, United Arab Emirates*. New Haven: Yale University Press, pp. 28–37.

Whybrow, P.J. and Hill, A. (eds.). 1999a. *Fossil Vertebrates of Arabia: With Emphasis on the Late Miocene Faunas, Geology, and Palaeoenvironments of the Emirate of Abu Dhabi, United Arab Emirates*. New Haven and London: Yale University Press.

Whybrow, P.J. and Hill, A. 1999b. Introduction to Fossil Vertebrates of Arabia. In: Whybrow, P.J. and Hill, A. (eds.), *Fossil Vertebrates of Arabia: With Emphasis on the Late Miocene Faunas, Geology, and Palaeoenvironments of the Emirate of Abu Dhabi, United Arab Emirates*. New Haven: Yale University Press, pp. 3–6.

Whybrow, P.J. and Hill, A. 2002. Late Miocene fauna and environments of the Baynunah Formation, Emirate of Abu Dhabi, United Arab Emirates: The Mid-East "Monsoon"? *Annales Géologiques des Pays Helléniques* 34(A): 353–362.

Whybrow, P.J., Hill, A. and Kingston, J.D. 1999. Late Miocene fauna and environments of the Baynunah Formation: Emirate of Abu Dhabi (Western Region), United Arab Emirates. *Journal of the Faculty of Science: U.A.E. University* 10(1): 120–145.

Whybrow, P.J., Hill, A. and Smith, A.B. 1996. The fossil record. In: Vine, P. and Al Abed, I. (eds.), *Natural Emirates: Wildlife and Environments of the United Arab Emirates*. London: Trident Press, pp. 41–50.

Whybrow, P.J., Hill, A. and Smith, A.B. 1998. Fossils from the UAE's ancient environments. *Arabian Wildlife* 3: 42–45.

Whybrow, P.J., Hill, A. and Smith, A.B. 2005. The fossil record. In: Hellyer P. and Aspinall, S. (eds.), *The Emirates: A Natural History*. London: Trident Press, pp. 81–89.

Whybrow, P.J., Hill, A. and Yasin al-Tikriti, W. 1991. Miocene fossils from Abu Dhabi. *Tribulus* 1: 4–9.

Whybrow, P.J., Hill, A., Yasin al-Tikriti, W. and Hailwood, E.A. 1990. Late Miocene primate fauna, flora and initial paleomagnetic data from the Emirate of Abu Dhabi, United Arab Emirates. *Journal of Human Evolution* 19: 583–588.

Whybrow, P.J. and McClure, H.A. 1981. Fossil mangrove roots and palaeoenvironments of the Miocene of the eastern Arabian peninsula. *Palaeogeography, Palaeoclimatology, Palaeoecology* 32: 213–225.

Yasin al-Tikriti, W. 2005. The impact of archaeology on the palaeontology of the Western Region of Abu Dhabi: The history of palaeontological research. In: Beech, M. and Hellyer, P. (eds.), *Abu Dhabi 8 Million Years Ago: Late Miocene Fossils from the Western Region*. Abu Dhabi: Abu Dhabi Islands Archaeological Survey, pp. 10–13.

The Authors

FAYSAL BIBI works on the evolution of mammals, particularly with regards to the emergence of modern ecological systems. He is co-director with Andrew Hill of the Baynunah Paleontology Project in the Western Region of the Abu Dhabi Emirate, U.A.E., and has been leading expeditions to Abu Dhabi since 2003. He is a member of research teams working in Ethiopia and Kenya on the trail of human origins and has also conducted fieldwork in the United States, Lebanon, and Mongolia. Bibi received his Ph.D. from Yale University in 2009. He has been a fellow of the U.S. National Science Foundation at the University of Poitiers, a Leibniz-DAAD Fellow at the Museum für Naturkunde in Berlin, and a Gerstner Scholar at the American Museum of Natural History in New York.

فيصل بيبي يعمل على تطور الثدييات وخصوصاً ما يتعلق بظهور النُظم الإيكولوجية الحديثة. مدير مشروع البينونة الإحاثي بالاشتراك مع أندرو هيل. وهو يقود بعثات استكشافية في أبوظبي منذ 2003. عضو فرق بحثية تعمل في إثيوبيا وكينيا تتعقب آثار أصول الإنسان. أجرى أعمالا ميدانية في الولايات المتحدة ولبنان ومنغوليا. حاز درجة الدكتوراه من جامعة يال الأميركية في العام 2009. زميل "المؤسسة الوطنية للعلوم في الولايات المتحدة" لدى جامعة بواتييه الفرنسية، وزميل "لايبنتس DAAD" في متحف التاريخ الطبيعي في برلين، وباحث "جيرسْتنر" في متحف التاريخ الطبيعي في نيويورك.

ANDREW HILL had a lifelong interest in the evolution of apes and humans, and in the associated changes in faunas and environments. He first worked in Abu Dhabi in 1984, and ran an expedition there with Peter Whybrow of the Natural History Museum, London. Co-director with Faysal Bibi of the Baynunah Paleontology Project, he was also director of a long-running multidisciplinary research expedition in the Tugen Hills of Kenya. He received his Ph.D. from the University of London, then held various positions in the National Museums of Kenya and the International Louis Leakey Memorial Institute of African Prehistory. This was followed by a research fellowship at Harvard University. Hill joined the faculty of Yale University in 1985, where he was the Clayton Stephenson Professor of Anthropology, and Curator and Head of the Division of Anthropology at the Yale Peabody Museum of Natural History.

أندرو هيل (1946–2015) اهتم بتطور القردة والبشر والتغيرات في عالم الحيوان والبيئات المرتبطة بها. بدأ عمل هيل في أبوظبي في العام 1984 وقاد بعثة هناك بالاشتراك مع بيتر وايبرو (من متحف التاريخ الطبيعي في لندن). فضلاً عن مشاركة فيصل بيبي في إدارة مشروع البينونة الحالي فهو ادار بعثة أبحاث طويلة الأمد ومتعددة الحقول في تلال "توجن" الكينية. حاز درجة الدكتوراه من جامعة لندن ثم شغل مناصب مختلفة في متحفي التاريخ الطبيعي في كينيا و"معهد لويس ليكي التذكاري الدولي حول أفريقيا ما قبل التاريخ". تلا ذلك زمالة بحث في جامعة هارفارد. التحق بجامعة يال الأميركية في 1985 حيث احتل كرسي كليتون ستيفنسون في علم الإنسان (الأنثْروبولوجيا)، وكان قيّم ورئيس قسم علم الإنسان في متحف بيبودي للتاريخ الطبيعي حتى وفاته..

المؤلفون

MARK BEECH is an archaeologist interested in the prehistory of the Arabian peninsula. Since 2006 he has worked in the Department of Historic Environment at the Abu Dhabi Tourism and Culture Authority in Abu Dhabi, where he is Head of Coastal Heritage and Palaeontology as well as team leader of the Abu Dhabi component of the Baynunah Paleontology Project team. He received his Ph.D. from the University of York in the United Kingdom in 2001, where his thesis work focused on the history of fishing in the Arabian Gulf from the Neolithic to the Islamic period. Beech has carried out both archaeological and paleontological fieldwork in Abu Dhabi since 1994. In 2009 Sheikh Nahyan bin Mubarak Al Nahyan, the U.A.E. Minister of Higher Education and Scientific Research, presented him with the Sheikh Mubarak bin Mohammed Prize for Natural History for his services to archaeology and natural history in the United Arab Emirates.

مارك بيتّش عالم آثار مهتم بتاريخ ما قبل تاريخ الجزيرة العربية. يعمل منذ 2006 في دائرة البيئة التاريخية التابعة لهيئة أبوظبي للسياحة والثقافة، في الإمارات العربية المتحدة. وهو مدير قسم تراث الساحل والباليونتولوجيا ومسؤول فريق أبوظبي في مشروع البينونة الإحاثي. حاز درجة الدكتوراه من جامعة يورك في المملكة المتحدة في العام 2001 عن رسالته عن تاريخ صيد السمك في الخليج العربي من العصر النيوليثي (الحجري الحديث) حتى العصر الإسلامي. يجري بيتش في أبوظبي أعمالاً ميدانية، آركيولوجية وإحاثية، منذ 1994 . وفي العام 2009 منحه وزير التعليم العالي والبحث العلمي في الإمارات العربية المتحدة، الشيخ نهيان بن مبارك آل نهيان، جائزة الشيخ مبارك بن محمد للتاريخ الطبيعي تقديراً لخدماته لعلم الآثار والتاريخ الطبيعي في الإمارات العربية المتحدة.

Credits مصادر الصور

page vi–1, 26, 33 (left), 47 (top), 50 (middle), 77 (middle), 84, 92, 97 (left), 103 (left), cover (cliff face): Mark Beech

page 2: Adapted from © 2007 Google Earth: ©2009 Cnes/Spot Image; ©2009 DigitalGlobe; Data SIO, NOAA, U.S. Navy, NGA, GEBCO / Faysal Bibi

page 2–3, 8, 10 (left), 15 (left), 16, 24–25, 25 (bottom), 28, 29, 33 (right), 36, 37 (top), 45 (A, C), 46 (A, B), 47 (bottom), 49, 50 (top, bottom), 51 (top left), 52, 53 (bottom), 55, 56, 59 (middle, bottom), 61, 62 (bottom), 63 (bottom), 64, 68–69, 70 (A, B, C, D), 73 (left), 74, 75 (left), 77 (bottom), 78, 79, 80, 81, 82, 83, 84 (inset), 87, 88, 95, 96 (left, middle left, right), 97 (middle), 102 (right), 103 (right), 104, cover (fossil shells): Faysal Bibi

page 5: Graham, Joseph, William Newman, and John Stacy. 2008. "The geologic time spiral—A path to the past" (ver. 1.1): U.S. Geological Survey General Information Product 58, poster, 1 sheet. Available at *http://pubs.usgs.gov/gip/2008/58/*

page 10–11: Artwork by Chase Studio

page 12–13: Gemma Goodall, Antares Design

page 15 (right), 23, 24 (bottom), 27 (top), 42, 45 (B), 72, 73 (middle), 89, 97 (right), cover (fossil crocodile skull): Andrew Hill

page 19: Adapted from Petraglia, Michael D., Abdullah Alsharekh, Paul Breeze, Chris Clarkson, Re Crassard, Nick A. Drake, Huw S. Groucutt, Richard Jennings, Adrian G. Parker, Ash Parton, Richard G. Roberts, Ceri Shipton, Carney Matheson, Abdulaziz al-Omari, and Margaret-Ashley Veall. 2012. "Hominin dispersal into the Nefud Desert and Middle Palaeolithic settlement along the Jubbah Palaeolake, northern Arabia." *PLoS ONE* 7(11):e49840. doi:10.1371/journal.pone.0049840; © 2012 M. D. Petraglia, A. Alsharekh, P. Breeze, C. Clarkson, R. Crassard, N. A. Drake, H. S. Groucutt, R. Jennings, A. G. Parker, A. Parton, R. G. Roberts, C. Shipton, C. Matheson, A. al-Omari, and M.-A. Veall / CC BY 4.0

page 20 (top): ©2010 Google Earth: U.S. Geological Survey; ©2010 DigitalGlobe

page 20 (bottom): ©2010 Google Earth: ©JAXA, METI, analyzed by JAXA; U.S. Geological Survey; ©2010 DigitalGlobe

page 21: ©2010 Google Earth: ©2010 GeoEye; ©2010 DigitalGlobe; Data SIO, NOAA, U.S. Navy, NGA, GEBCO; U.S. Geological Survey

page 27 (inset), 91: Daniel Peppe

page 31, 40, 41, 44, 45 (top right), 46 (left), 48, 51 (right), 53 (top), 56–57, 59 (top), 76: Art by Mauricio Antón

page 34–35: Mark Beech / Faysal Bibi

page 37 (bottom), 38–39: From Bibi, Faysal, Brian Kraatz, Nathan Craig, Mark Beech, Mathieu Schuster, and Andrew Hill. 2012. "Early evidence for complex social structure in Proboscidea from a late Miocene trackway site in the United Arab Emirates." *Biology Letters* 8(4):670–673. doi: 10.1098/rsbl.2011.1185; © 2012 F. Bibi, B. Kraatz, N. Craig, M. Beech, M. Schuster, A. Hill

page 58, 62–63 (top), 65, 66, 73 (right), cover (fossil footprint): Brian P. Kraatz

page 54: Jean-Renaud Boisserie

page 68: From Pettigrew, J. Bell. *Animal Locomotion* (New York: D. Appleton & Company, 1874). "Skeleton of ostrich." Courtesy of FCIT (*http://etc.usf.edu/clipart*)

page 70 (right): Wikimedia Commons, public domain / *commons.wikimedia.org/wiki/Anhinga_rufa#/media/File:Anhingarufa1.JPG*

page 75 (right): Dewet / *Wikimedia Commons* / *CC BY-SA 2.0* / *commons.wikimedia.org/wiki/File:NileCrocodile.jpg*

page 77 (top): Wikimedia Commons, public domain / *commons.wikimedia.org/wiki/File:Gaviál_indický.jpg*

page 85: Rafael Brix / *Wikimedia Commons* / *CC BY-SA 3.0* / *en.wikipedia.org/wiki/File:Scarabaeus_laticollis_2.jpg*

page 96 (middle right): Ahmed Abdalla El Haj

ينشر بدعم من هيئة أبوظبي للسياحة والثقافة، الإمارات العربية المتحدة. توزيع منشورات جامعة يال، نيوهافن ولندن.
yalebooks.com | yalebooks.co.uk

حقوق النص والصور الفوتوغرافية والرسوم لفيصل بيبي وأندرو هيل ومارك بيتش، عدا ما يشار على غير ذلك. جميع الحقوق محفوظة

تصميم الكتاب: ماوْرا جياناكوس (خدمات جامعة يال للطباعة والنشر) ومارك سابا (خدمات يال للمعلومات والتكنولوجيا).

Peabody Museum of Natural History
متحف بيْبودي للتاريخ الطبيعي، جامعة يال
Yale University
P. O. Box 208118
New Haven CT 06520-8118 USA

Printed in the U.S.A. by GHP Media, Inc.,
West Haven, Connecticut
Library of Congress Control Number: 2016025556
ISBN: 978-193378907-1
This paper meets the requirements of ANSI/NISO Z39.48-1992 (Permanence of Paper).
10 9 8 7 6 5 4 3 2 1

المحتويات

ملخص	2	القردة	59
الزمن الجيولوجي	7	القوارض	67
ما هو الأُحفور - أو المستحاثة؟	11	الطيور	71
البيئات المتحجرات ونهر البينونة	17	الزواحف	77
الأنهر العربية	21	الاسماك	79
طبيعة منطقة الغربية	29	القواقع وبلح البحر	81
الفِيَلة	43	الحشرات	85
اللواحم	47	النباتات	89
الزرافات	49	تقديم	93
الظِّباء	51	امتنان	94
الخيول	53	الاستكشاف الأحفوري في أبوظبي: تاريخ موجز	97
البرنيق - أو فرس النهر	55	قراءات مزيدة	98
الخنازير	57	المؤلفون	104
		مصادر الصور	105

His Excellency Mohammed Khalifa Al Mubarak

Chairman of Abu Dhabi Tourism and Culture Authority

The Abu Dhabi Tourism and Culture Authority (TCA Abu Dhabi) has policies and programmes that extend to protecting all palaeontological and archaeological sites discovered within the Emirate of Abu Dhabi.

With the longest coastline in the United Arab Emirates, Al Gharbia has some of the most dramatic landscapes known in the region. Abu Dhabi between 6 and 8 million years ago was an area quite different from today's arid environment. A very extensive river system flowed slowly through the area, along which was flourishing vegetation including large trees. Many kinds of animals were sustained by this environment, including elephants, hippopotamuses, antelopes, giraffes, pigs, monkeys, rodents, small and large carnivores, ostriches, turtles, crocodiles, and fish.

This book goes some way towards highlighting some of the beautiful locations where fossils can be found in Al Gharbia, which should be preserved for future generations to enjoy. The fossil sites presented here are of international importance and need to be protected so that future palaeontologists may conduct further research into the hidden riches of Abu Dhabi's Western Region.

سعادة/ محمد خليفة المبارك

رئيس مجلس إدارة هيئة أبوظبي للسياحة والثقافة

تتبنى هيئة أبوظبي للسياحة والثقافة سياسات وبرامج تمتد لتشمل حماية كافة المواقع الخاصة بعلم الأحياء القديمة والمواقع الأثرية التي تُكتشف في إمارة أبوظبي.

على امتداد الساحل الأطول في الدولة، تحتوي المنطقة الغربية على أكثر المواقع التضاريسية تنوعاً والمعروفة في المنطقة. لقد كانت أبوظبي قبل 6 إلى 8 ملايين عام منطقة مختلفة اختلافاً تاماً عن بيئتها الجافة المعاصرة؛ كانت هناك أنهار تتدفق ببطء من خلال المنطقة وتنمو بمحاذاتها حياة نباتية غنية بما في ذلك الاشجار الكبيرة. كما احتوت هذه البيئة على العديد من الحيوانات من بينها الأفيال وأفراس النهر والظباء والزراف والخنازير والقرود والقوارض وآكلات اللحم الصغيرة والكبيرة والنعام والسلاحف والتماسيح والسمك.

يسلط هذا الكتاب الضوء على بعض مواقع الأحافير في المنطقة الغربية التي يجب المحافظة عليها للأجيال القادمة. إن مواقع الأحافير التي نتناولها هُنا تحظى بأهمية دولية، ويجب حمايتها حتى يتسنى لعلماء الأحياء القديمة مستقبلاً لإجراء المزيد من الدراسات و البحوث حول الأحفوريات الغير متكشفة في المنطقة الغربية من إمارة أبوظبي.

His Highness Sheikh Hamdan bin Zayed Al Nahyan

Ruler's Representative in the Western Region, Abu Dhabi

The Western Region is an important part of the Emirate of Abu Dhabi, embodying authentic Bedouin life and providing an important series of historical landmarks in the long history of the United Arab Emirates.

The Baynunah geological formation features a number of fossil sites of national and global significance. These sites date to the Late Miocene period, between 6 to 8 million years ago, and are considered to represent some of the best exposures of such fossils to be found anywhere in the world.

The late Sheikh Zayed bin Sultan Al Nahyan once said, "A people that knows not its past has no present nor future." If we are to fully understand the past then we must recognize the nature of the land, and in order to fulfill our responsibility to provide for future generations, it is our duty to protect the exceptional cultural value of these sites in the Western Region.

I hope that this book will be an important contribution to increasing awareness of the scientific importance of these sites. It will be a useful reference for the study of the ancient environments of earlier epochs in the Western Region, which will be a source of pride for the United Arab Emirates.

سمو الشيخ حمدان بن زايد آل نهيان
ممثل الحاكم في المنطقة الغربية – أبوظبي

تعد المنطقة الغربية جزءا مهما من إمارة أبوظبي وتجتمع فيها كل معالم الحياة البدوية الأصيلة التي تجسّد مرحلة من التاريخ الإماراتي العريق.

كما تحظى بعمق الموجودات الثقافية حيث يضم تشكيل بينونة الجيولوجي عددا من مواقع الأحافير ذات الأهمية الوطنية والعالمية.

ويعود تاريخ هذه المواقع الى العصر الميوسيني المتأخر أي قبل 6 الى 8 ملايين عام ، وتعتبر هذه الطبقة الغنية بالمتحجرات من أفضل مواقع الأحافير المكتشفة في العالم.+

من الأقوال المأثورة للمغفور له بإذن الله الشيخ زايد بن سلطان آل نهيان " من ليس له ماض ، ليس له حاضر أو مستقبل " لذا فإننا إذا أردنا أن نفهم ماضينا الفهم الكامل ، فيجب علينا أن ندرك طبيعة الأرض وأن نقوم بمسؤوليتنا بتقديمها الى الأجيال القادمة ، فإنه من الواجب علينا حماية هذه المواقع ذات القيمة الثقافية الإستثنائية في المنطقة الغربية.

أرجو أن يكون هذا الكتاب مساهمة مهمة في زيادة الوعي بالأهمية العلمية لتلك المواقع ، وأن يكون مرجعا مفيدا لعلم دراسة الأحياء القديمة في العصور السالفة في المنطقة الغربية ، الأمر الذي سوف يكون مصدر فخر وإعتزاز لدولة الامارات العربية المتحدة..

ألف أحفور وأحفور

اكتشافات من الزمن السحيق في صحراء الغربية، أبوظبي- الإمارات العربية المتحدة

متحف بيبودي للتاريخ الطبيعي، جامعة يال، نيو هافن، الولايات المتحدة الأمريكية

هيئة ابو ظبي للسياحة والثقافة، الإمارات العربية المتحدة

فيصل بيبي أندرو هيْل مارك بيتْش

ألف أحفور وأحفور

560	Bibi, F.
.95	A thousand and one fossils.
357	Aurora P.L. NOV17
BIB	33164300214363